IMAGES
of America

AROUND
CHADDS FORD

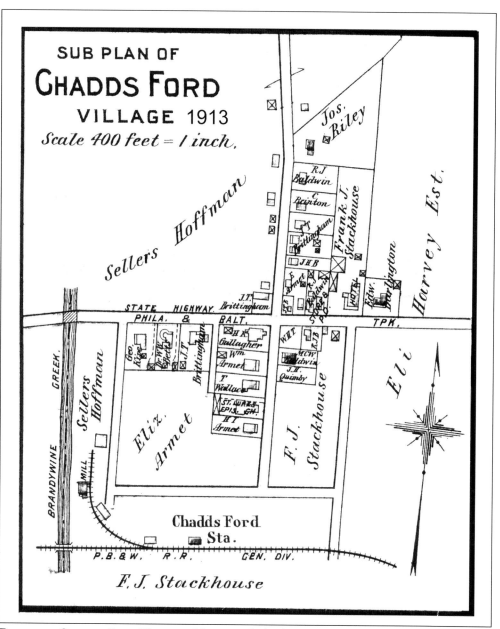

DETAIL OF CHADDS FORD VILLAGE. Names and plot locations of homeowners can be seen in this detail from a 1913 Birmingham Township map.

IMAGES
of America

AROUND
CHADDS FORD

Karen Smith Furst

ARCADIA

First published 2005

Published by Arcadia Publishing,
Charleston SC, Chicago IL, Portsmouth NH, San Francisco CA

Printed in Great Britain

Library of Congress Catalog Card Number: 2004106822

For all general information, contact Arcadia Publishing:
Telephone 843-853-2070
Fax 843-853-0044
E-mail sales@arcadiapublishing.com
For customer service and orders:
Toll-free 1-888-313-2665

Visit us on the Internet at www.arcadiapublishing.com

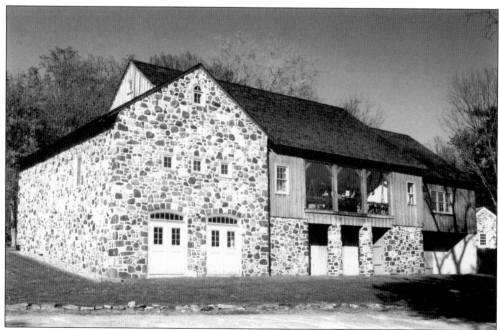

THE BARN VISITORS CENTER, 1998. The Chadds Ford Historical Society was founded in 1968 to save the crumbling *c.* 1725 John Chads House. Not long after, the society purchased the nearby Barns-Brinton House, built in 1714 by blacksmith and tavernkeeper William Barns. Both houses were restored and opened to the public. In 1991, the society built its headquarters building, the Barn Visitors Center, with exhibit, library, office, and storage space.

CONTENTS

ACKNOWLEDGMENTS

Many people contributed their photographs, time, memories, and knowledge to make this book a reality. The author gratefully thanks Donald W. Altmaier, the estate of Thomas B. Andress, Thomas B. T. Baldwin, Bernard J. Cialini, the Christian C. Sanderson Museum, Irénée du Pont Jr., Arthur H. Cleveland III, Janice Friel, Andrew C. Furst, Frank Gray, Frank Guest, Janet Darlington Haldeman, Susan Hauser, Robert Hempton, Frank Mendenhall, Richard B. Miller, Jean M. Oakes, David and Susan Poston, Sonia Ralston, Earl and Rebecca Rogers, Elizabeth Y. Rump, Sara Kipe Sharp, Janet F. Smith, Betty Luke Stiegler, David G. Taylor, Thomas R. Thompson, Kathleen C. Wandersee, Carla Westerman, Margaret Winkler, and Louis R. Wonderly.

INTRODUCTION

Originally a place-name coined by travelers who forded the Brandywine River near land owned by John Chads, Chadds Ford grew into a village that encompassed land along both sides of "Ye Great Road to Nottingham"—today's Route 1. Located in southeastern Pennsylvania, Chadds Ford today includes parts of Bethel, Concord, and Chadds Ford Townships in Delaware County, as well as parts of Birmingham, Pennsbury, and Kennett Townships in Chester County.

Chadds Ford is well known for its Colonial history. The area was inhabited by the Lenni Lenape when the first Swedish explorers trekked up the Brandywine in 1638. By 1700, English Quakers made up the largest demographic. They built mills and houses and carved out farmland along the fertile banks of the Brandywine. Farmers grew flax, wheat, and rye, and produced butter and cheese to sell at market in Philadelphia, one day's trip away.

The quiet country life enjoyed by Chadds Ford residents was shattered in September 1777 as Colonial troops gathered along the eastern bank of the Brandywine. George Washington had chosen this spot to halt the march of Sir William Howe's British army toward Philadelphia. Washington's effort failed. After a day of fierce fighting, the Colonial troops retreated in disarray as Howe camped on the battlefield for five days and his army looted area homes.

The first half of the 19th century brought little change to Chadds Ford; the area remained rural and agricultural. Farms, blacksmith shops, and mills—along with those businesses needed for small-town life, including an inn and a general store—composed the architectural landscape. The late 1850s, however, saw an exciting new change, not only in transportation but in the enlargement of the country person's world view: the railroad came to town. Two lines were built in Chadds Ford: the Philadelphia and Baltimore Central (running east–west) and the Wilmington and Northern (running north–south). With the railroads came people, including wealthy Philadelphians looking for the perfect pastoral setting in which to build summer homes. They found just that in Chadds Ford.

Despite the influx of these new people, many of whom found the town so much to their liking that they took up permanent residence, early-20th-century Chadds Ford was still a quiet crossroads surrounded by acres of farmland. All that changed dramatically after World War II. Better roads and faster cars, the population explosion of the 1950s, and shifting urban demographics drove people from the cities into the countryside. Housing developments were carved out of farms, changing Chadds Ford's landscape from rural to suburban.

Most of the photographs in this book date from about 1870 to 1950, when Chadds Ford enjoyed the sophistication brought by the wealthy newcomers of the late 19th century, but still retained its rural flavor. This was the Chadds Ford extensively documented by local

amateur photographer Edward J. Shimer Seal (1896–1955), some of whose photographs are featured in these pages. His collection—along with many other wonderful images donated by various individuals—is now preserved in the archives of the Chadds Ford Historical Society, and totals more than 1,000 photographs of people and places in and around "the Ford." Some of the most interesting photographs are the images of the early businesses, particularly the blacksmith's shop and the Gallagher General Store. Some of the structures that once housed these shops have been torn down and replaced with new buildings and businesses. Other outstanding images are those of the individuals who lived in Chadds Ford. Farmers, mechanics, shopkeepers, and women and children, as well as local characters such as Christian C. Sanderson, come to life to provide a fascinating glimpse into our past.

One

SCENIC VIEWS
AND TOWNSCAPES

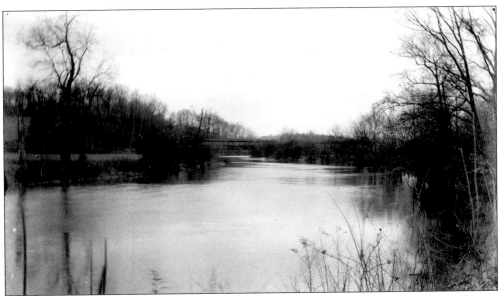

A SCENIC VIEW OF THE BRANDYWINE, C. 1930. Chadds Ford developed along the Brandywine River, which runs 60 miles from two sources in the Welsh Mountains near the western boundary of Chester County, and empties into the Delaware River at Wilmington, Delaware.

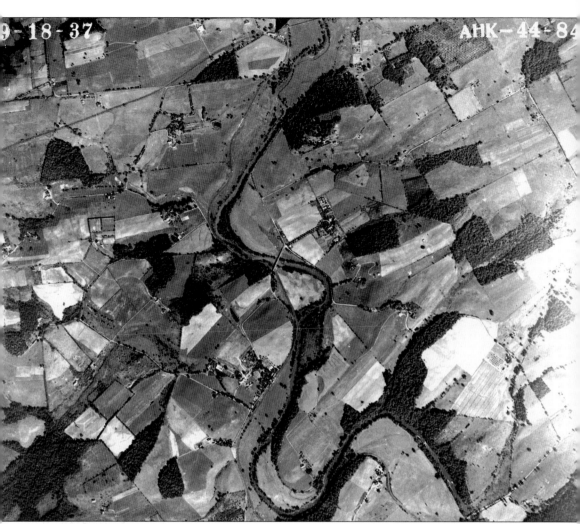

AN AERIAL VIEW, 1937. The Brandywine—called Fish Kihl (creek) by the Swedes, Wawaset by the Lenni Lenape, and Bränwin's Creek on old maps—defies certain identification of the origin of its name. Perhaps the most colorful story on this subject recounts a brandy-laden Dutch vessel that wrecked within the mouth of the stream in 1655; the Dutch word for brandy, *brandewijn*, thereafter became the name the river. It seems more likely, however, that the waterway was named for Andrew Braindwine, who received a land grant near the river mouth in 1670. As seen in this aerial view, the Brandywine south of Chadds Ford meanders through farmland. Visible in the center of the photograph are the Twin Bridges and the part of the river called the Big Bend.

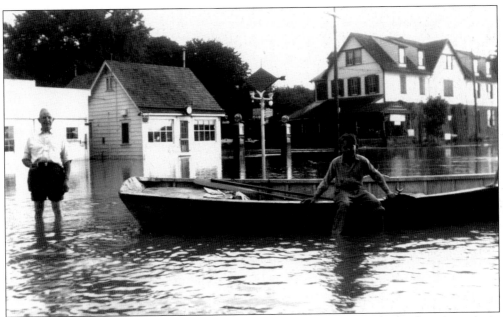

A Flood in Downtown Chadds Ford, August 1942. The Brandywine has always been prone to flooding. Here, a foot of water washes over downtown Chadds Ford. Both buildings seen in this photograph have been torn down. The gas station, at left, has been replaced with a long building that houses the post office and First Keystone Bank. The Gallagher General Store, at right, has been replaced by Leader Sunoco. The man standing on the left is Horace Quimby; the boy on the boat is unidentified. (Courtesy the Christian C. Sanderson Museum.)

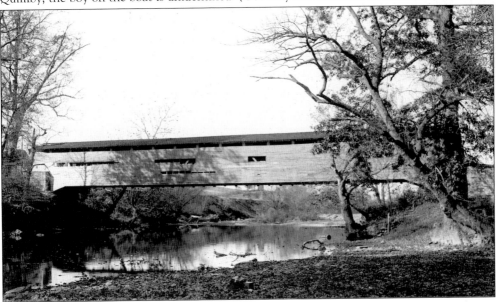

A Bridge in Chadds Ford, c. 1900. Travelers along "Ye Great Road to Nottingham," today's Route 1, were obliged to cross the Brandywine at Chadds Ford. To accommodate them, John Chads opened a ferry service in 1737, but crossing continued to be difficult in flooded conditions. Finally, in 1829, a 200-foot, open wooden bridge was built. It was replaced in 1860 by a covered bridge costing $5,490.

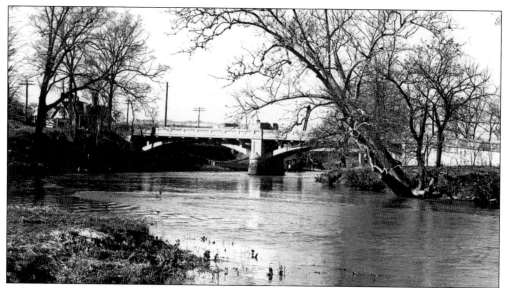

A BRIDGE OVER THE BRANDYWINE, C. 1938. The covered bridge in the previous photograph was replaced with this $78,000 open concrete bridge in 1921. It was rebuilt in 1938, when the road was widened. Each bridge built at this location was placed slightly to the north of the previous one. In this north-looking view, the top of the new Chadds Ford Consolidated School is behind the bridge. Also visible is a construction crane. The building to the left is today Taylor's Service Station.

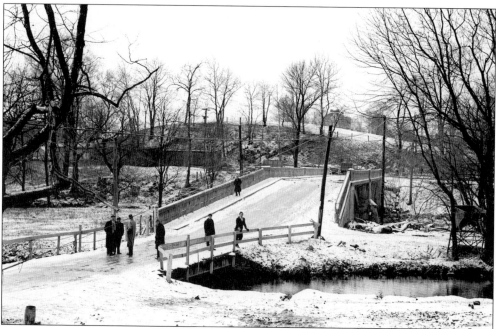

THE TWO-LANE BRIDGE OVER THE BRANDYWINE, C. 1930. The bridge seen in the preceding images is shown here in a westward view. The house in the background belonged to Swithin Walker when the photograph was taken, but the house is no longer standing. N. C. Wyeth boarded in the house when he first came to Chadds Ford (in 1903). At that time the property was known as the Strode Farm and was rented to the Pusey Taylor family.

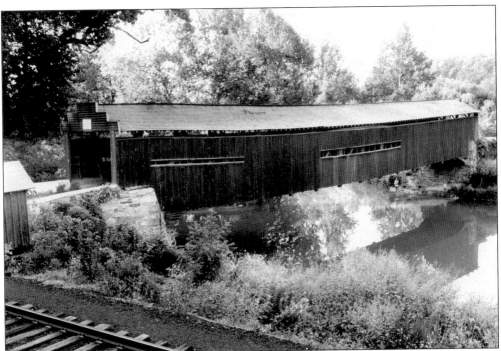

BRINTON'S BRIDGE, 1957. This 140-foot-long covered bridge was built over the Brandywine north of Chadds Ford in 1854 by Robert Russell at a cost of $3,060. It was destroyed by fire in 1957 and was never rebuilt. The stretch of road approaching the bridge became a private drive, creating two Brinton's Bridge Roads, one on either side of the Brandywine. This northeast-facing view shows the distinctive stepped front of the bridge and the railway on the west side of the river.

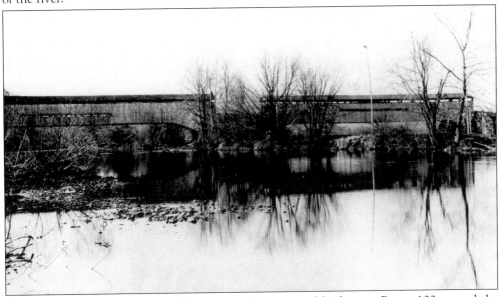

THE TWIN BRIDGES, C. 1920. These two in-line covered bridges on Route 100 crossed the Brandywine about one and a half miles south of Chadds Ford. Built about 1852, the bridges were supported by a common pier in the middle.

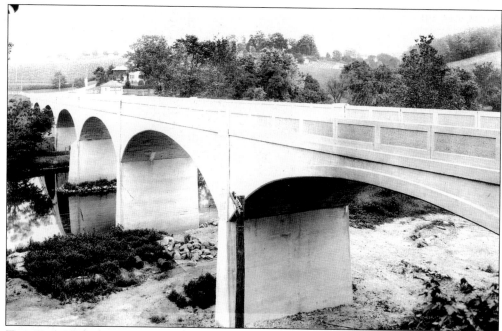

THE TWIN BRIDGES, 1926. In 1926, the twin covered bridges were replaced with a new concrete bridge. The cement was supplied by Harry Pyle and Sons. A single railway track and a dirt road went underneath the new bridge on the south side of the Brandywine. The railway line went from Elsmere, Delaware, to Coatesville, Pennsylvania. The dirt road was known as Stabler Road; it connected with Chadds Ford–Fairville Road on the north and Route 100 just south of the bridge.

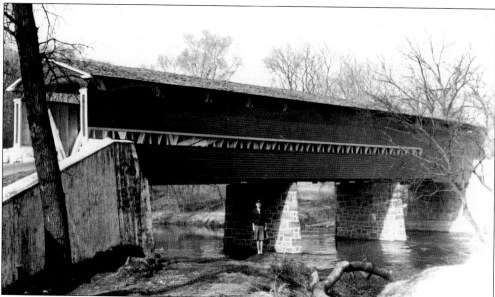

SMITH'S BRIDGE, 1955. Located just over the Delaware state line, this Burr-truss covered bridge was built in 1839. It was reinforced with piers and steel beams in 1956. Five years later, it was destroyed by fire but was quickly rebuilt as an open wooden structure. In 2002, at the urging of local residents, the original bridge with the Burr trusses was reconstructed.

BALTIMORE PIKE AT WEBB ROAD, EARLY 1900s. This thoughtfully composed photograph shows a snow-covered and desolate Route 1. Opened about 1737, the road from Philadelphia to Baltimore was incorporated in 1810 by a turnpike company. With encouragement from the state—which had no funds for road maintenance—turnpike companies sold stock in a road, paid dividends, and charged tolls. Companies such as these became obsolete with the construction of railroads.

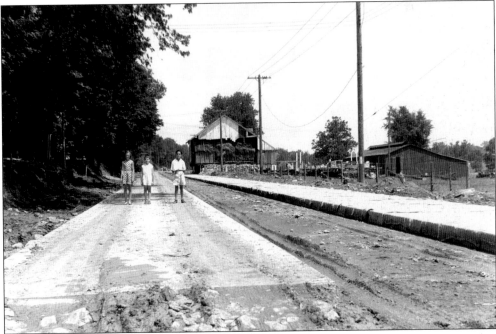

WIDENING ROUTE 1, C. 1938. First paved with concrete about 1917, Route 1 was widened to three lanes in the 1930s. In this east-facing view, Betty Oakes (left), Thomas Andress (center), and an unidentified boy pose for the camera. Pyle's Barn (center background) was later moved and rebuilt. It now houses a real-estate office.

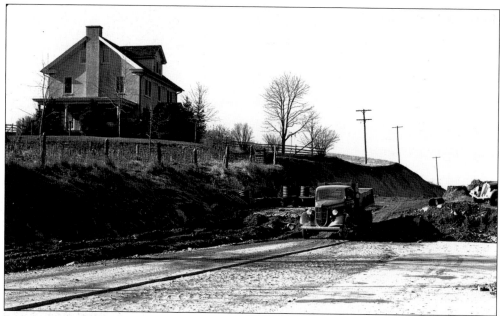

ROUTE 1 RECONSTRUCTION, C. 1938. This is a west-facing view of the Route 1 construction project that leveled and widened the two-lane highway to three lanes. The house to the left, once owned by Roland McFadden, is still standing across from the Chadds Ford Elementary School.

ROUTE 100, C. 1940. Route 100 runs from Wilmington, Delaware, to Reading, Pennsylvania. In this north-facing view toward Route 1, both the railway bridge seen in the distance and the small house at the right have been torn down.

ROUTE 100, SOUTH OF CHADDS FORD, C. 1930. Heading south on Route 100 from Chadds Ford, one can still see the building to the left. It was used first as a schoolhouse and later as studio space and housing for members of the Wyeth family. The house seen through the trees to the right was owned by John McVey.

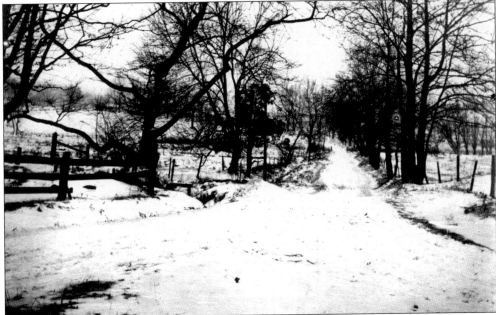

RING ROAD, EARLY 1900S. The property around Ring Road from Route 1 to the railroad tracks was owned by members of the Atwater and Cleveland families at the time this south-looking photograph was taken. In 1940, the farm was acquired by Karl Kuerner, whose son recently deeded it to the Brandywine Conservancy. N. C. Wyeth died nearby on October 19, 1945, when his car was hit by a train. His grandson and namesake, Newell Convers Wyeth, who was in the car with him, was also killed.

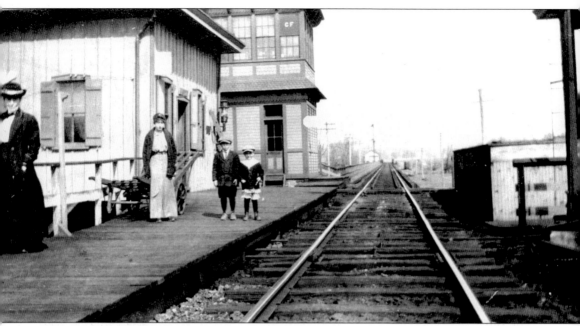

CHADDS FORD JUNCTION RAILROAD STATION, C. 1915. In 1855, the Philadelphia and Baltimore Central Railroad approached Birmingham Township farmer Joseph P. Harvey about building a track on part of his 197 acres. Harvey agreed but required the railroad company to provide a cattle pass and fencing to be kept in "good order and repair at all times hereafter." The railroad complied, and in 1858, the east–west line was constructed just south of today's Route 1.

A few years later, the Wilmington and Northern Railroad was established on the west side of the Brandywine in Pennsbury Township. The two lines met at Chadds Ford Junction Station. The addition of the word *junction* differentiated this depot from Chadds Ford Station, located at the end of Station Way Road on the east side of the Brandywine, just a few hundred yards away. Both passenger and freight trains ran on this line, and trains were instructed to come to a complete stop before crossing the Philadelphia and Baltimore Central track.

The tracks in the photograph extend eastward (away from the viewer) toward Chadds Ford Station on the other side of the Brandywine, and then to Philadelphia. The cross tracks at the "junction," seen just beyond the children, is the Wilmington and Northern Railroad. Traveling north, one would go to Lenape, Northbrook, Coatesville, Elverson, and Reading. Traveling south (down the track at right), one would go to Wilmington. There are still tracks that cross Route 1 just west of the Brandywine, near the Chadds Ford Elementary School.

Stationmaster Harry Smith was a boarder at the Gallagher house. On his way to work each day, Smith routinely passed by the house of the town doctor, William Betts. Betts's daughter Florence remembers the stationmaster: "You could set your clock by the time that he walked by the house to be at the station when it was open. He kept a very neat station."

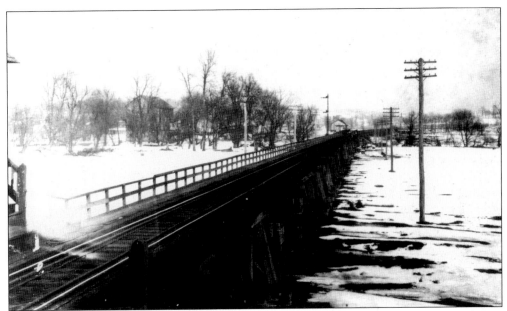

THE RAILROAD BRIDGE ACROSS BRANDYWINE AT CHADDS FORD, C. 1920. This view looks east across the Brandywine, toward the Chadds Ford Station. At the left (behind the trees) is Hoffman's Mill, which later became the Brandywine River Museum.

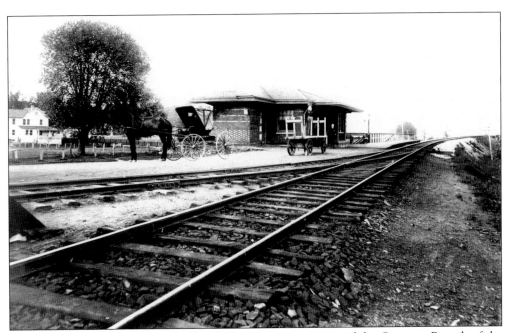

CHADDS FORD STATION, 1915. Chadds Ford Station was part of the Octoraro Branch of the Pennsylvania Railroad. Located at the end of Station Way Road (near the present-day Brandywine River Museum), this station is no longer in existence. In this eastward view, Station Way Road runs along the fence in the upper left-hand area of the photograph, behind the horse. The station was one of the best places to meet and greet fellow residents during a morning stop to pick up the daily newspaper, which was delivered by train from Philadelphia.

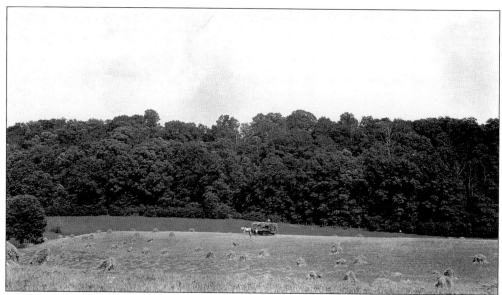

A WHEAT FIELD WITH HORSE AND WAGON, C. 1935. Chadds Ford was largely agricultural until just after World War II. Here, workers at Locust Knoll Farm (located southeast of the Twin Bridges) load a horse-drawn wagon with wheat to be hauled to the thresher. Note the shocks of wheat (cut bundles) in the foreground.

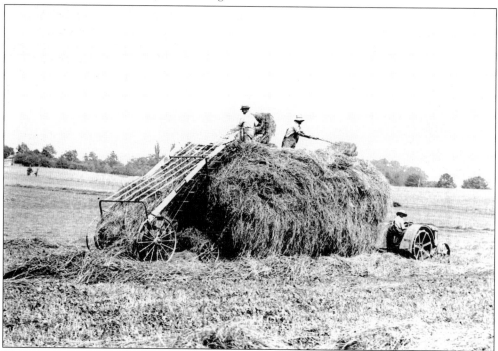

HAYING AT LOCUST KNOLL FARM, C. 1940. Haying was a typical farm operation around Chadds Ford in the first half of the 20th century. The mechanized hay lifter seen here became available to farmers in the early 1940s. Prior to that, farmers raked the hay into small piles and then used large two-pronged pitchforks to load the hay onto wagons like this one. The wagons were drawn by horses or tractors.

A Scenic View of Route 100 South, c. 1940. During the decades following World War II, the face of Chadds Ford began to change as farms were sold or subdivided and developments were built. Today, even though Chadds Ford is a rapidly growing community with a multitude of housing developments, much of the area is still open space, thanks to local land-preservation efforts.

Alongside Pierce Farm, c. 1930. Built about 1783 by members of the Smith family, the house and 109-acre property on Rocky Hill Road changed ownership numerous times (through the Taylor, Palmer, Kitts, and Bullock families), before James and Annie Pierce purchased the land in 1915. Though subsequently owned by the du Pont family, the property was still referred to as the Pierce Farm. The farm looks much the same today, although the upper part of Rocky Hill Road is now a private lane.

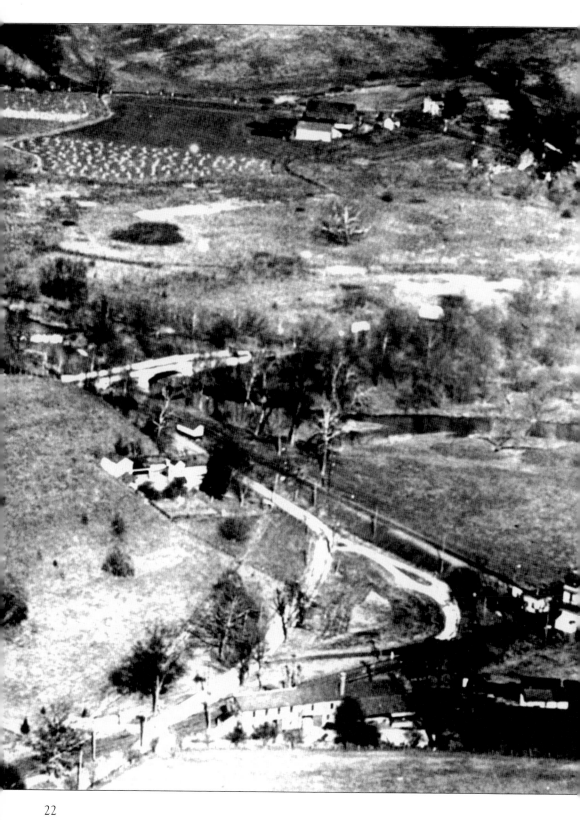

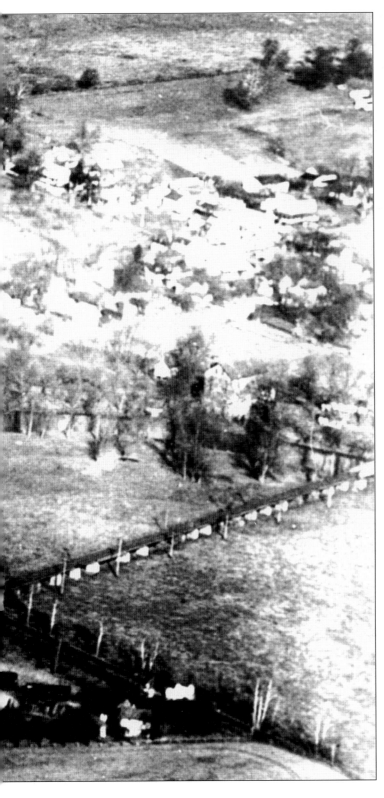

AN AERIAL VIEW OF CHADDS FORD, 1925. In the 1920s Chadds Ford (at the upper right in this view to the northeast) was a small village surrounded by rolling hills and farmland. Businesses included the Chadds Ford Inn, a barbershop, a post office, a creamery, a blacksmith shop, two churches, several stores, and a railroad station. North of town is the John Chads House. The barn across the street is now the headquarters of the Chadds Ford Historical Society. Farther south, Route 1 passes south of the building that once housed a creamery and is now home to Taylor's Service Station. The road has since been moved to pass to the north of the building. In the center, near the bottom of the picture, is Chadds Ford Junction, with its crossing rail tracks and Harry Pyle's lumber and freight yard. Swithin "Squire" Walker's stone house is to the left and has been torn down since. There were mushroom houses to the left, just out of frame.

A Scenic View toward Chadds Ford, c. 1920. This view looks north toward Chadds Ford from N. C. Wyeth's property, where his studio still stands. Route 100 runs diagonally across the picture and then ducks under the railroad track (right of center). Chadds Ford Inn, with its distinctive mansard roof, can be seen where Route 100 meets Route 1. To the left, one can see Hoffman's Mill, which is today the Brandywine River Museum.

Looking toward Chadds Ford Junction, c. 1920. Here the photographer has moved farther up the hill and has swung the camera to the northwest. The Wyeth studio is still in frame to the right. Chadds Ford Consolidated School is to the upper right. The Chadds Ford Junction railroad station is visible in the center middle distance.

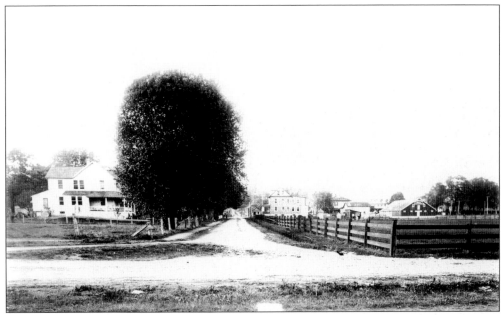

A VIEW OF CHADDS FORD, 1915. Traveling north on Station Way Road today, one would still see the house to the left and the brick building that houses Gentry's Tack Shop in the center. The Wawa convenience store, a bank, and the post office have replaced the barn to the right. Beyond peeks the Chadds Ford Hotel. The open field to the right has recently been filled by the Brandywine River Museum's new maintenance building.

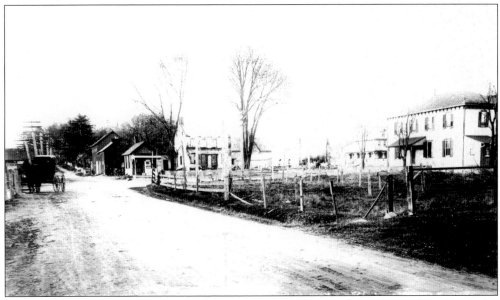

CHADDS FORD, 1915. From a vantage point a little farther north on Station Way Road, the photographer took aim at the burned-out Arment House (Wooden Knob today), to the left, and Baldwin's Store, to the right. Route 1, running in front, is just a dirt road, as is Station Way Road. The horse-drawn carriage to the left is parked in front of the Gallagher General Store (today Leader Sunoco). To the right, the Chadds Ford Inn is partially visible behind the Lippincott House.

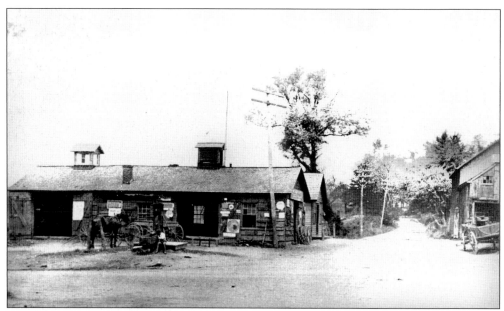

Looking Up the Creek Road, 1905. Heading north on what would someday become Route 100, an early-20th-century traveler might stop at John Brittingham's blacksmith shop to have a cartwheel repaired or a horse reshod. An early-21st-century traveler would find Hank's Place instead of the smithy. Surprisingly, both electricity and phone service were available when this photograph was taken—note the utility poles.

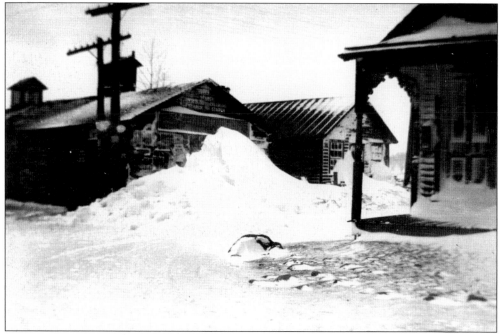

John Brittingham's Smithy, c. 1905. Chadds Ford village appears to be totally impassable during this c. 1905 blizzard. Local doctor William Betts had several methods for navigating rutted, unpaved roads: he made his rounds by horse and buggy in good weather, by horseback during flood season, and by sleigh in winter. By 1911, he began visiting patients by car.

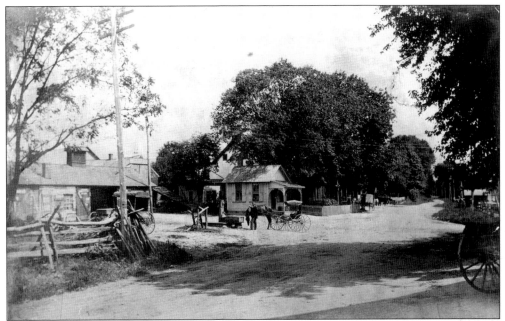

A VIEW OF CHADDS FORD, C. 1910. Here, a wider view to the east reveals "downtown" Chadds Ford. The man watering his horse at the trough in front of Brittingham's smithy serves as a focal point for the photograph. Today, this busy intersection sees thousands of vehicles whizzing through each day.

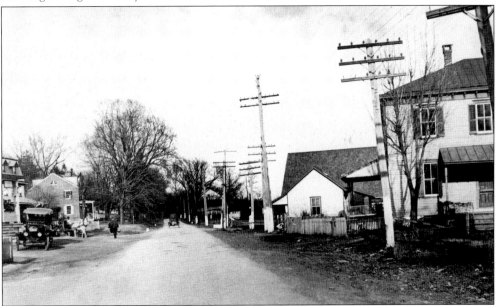

A VIEW OF CHADDS FORD, C. 1920. Route 1 (also called the Philadelphia Road and Baltimore Pike) was paved with concrete about 1917. This east-facing view shows the Chadds Ford Hotel at the left and, beside it, the building that now houses the Chadds Ford Gallery. At the far right is the Lippincott House, and to its right is a small building used as a barbershop. Note the presence of both automobiles and horse-drawn buggies, as well as telephone and electric wires. (Courtesy David G. Taylor.)

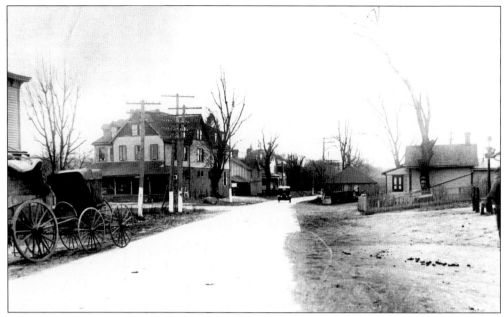

A VIEW OF CHADDS FORD, C. 1920. The photographer who took the previous picture turned 180 degrees to shoot this west-facing view. The large three-story building with porch (middle left) is the Gallagher General Store, where Leader Sunoco stands today. At the left, behind the buggies, the Lippincott House edges into the picture. Today, the Wawa occupies this location. (Courtesy David G. Taylor.)

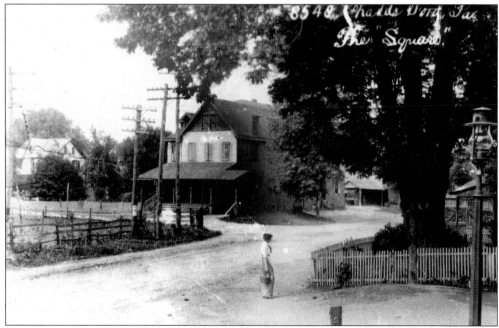

CHADDS FORD SQUARE, C. 1910. This slightly different and earlier view of the Gallagher General Store was taken from in front of Baldwin's Store, next to the Chadds Ford Inn. The Thomas Wallace House is to the left, down Station Way Road. The Arment House is to the right. An unidentified woman crosses the street. (Courtesy Bernard J. Cialini.)

Two

COMMERCE
AND WORSHIP

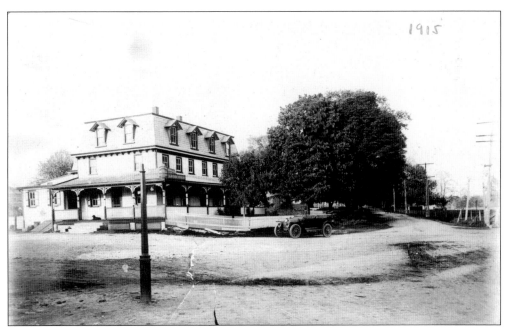

1915

THE CHADDS FORD HOTEL, 1915. The Chadds Ford Inn looks much the same today as it does in this photograph taken almost 90 years ago. At that time, the building was called the Chadds Ford Hotel and was owned by Frank Stackhouse. An early-vintage car is parked in the foreground on the unpaved road, and a horse-drawn buggy retreats eastward down the Philadelphia Road, today's busy Route 1.

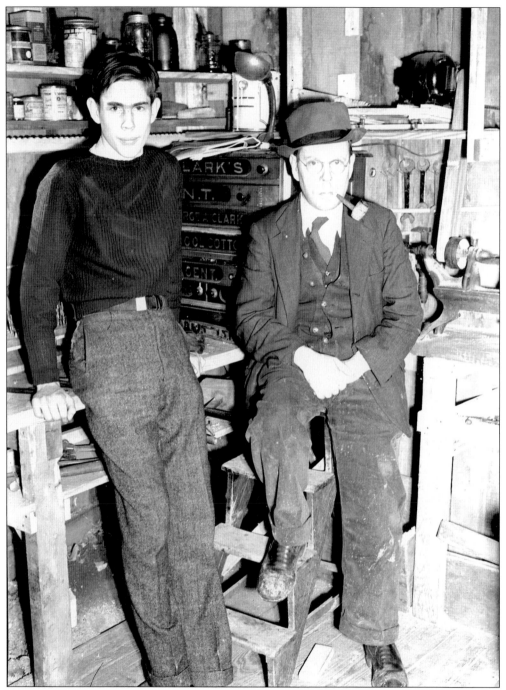

HERBERT GUEST AND HIS SON, C. 1935. In the 1930s, railroad worker Herbert William Guest Sr. (right) started an antiques business called Brandywine Antiques, located in the area where the Chadds Ford Barn Shoppes are today. The family lived in the brick house to the east of the Chadds Ford Inn; the house is now the Chadds Ford Gallery. Guest and his wife had two children: Herbert William Guest Jr. (left) and Frank Guest (not pictured). Both sons fought in World War II.

A CONESTOGA WAGON, c. 1935. Herbert William Guest Sr. poses with a Conestoga wagon for sale in his antiques shop. First made in Lancaster, Pennsylvania, Conestoga wagons were typically 16 feet long, 4 feet wide, and 4 feet deep, with a canvas top stretched over wooden hoops. The wooden wheels had bands of iron, like tires, around the rims. The wagon could carry 2,500 to 3,500 pounds.

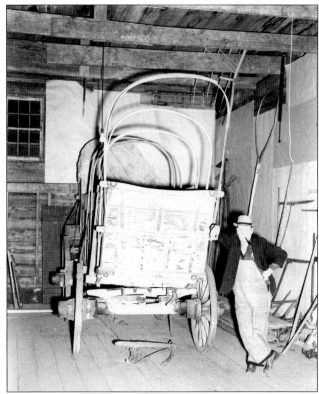

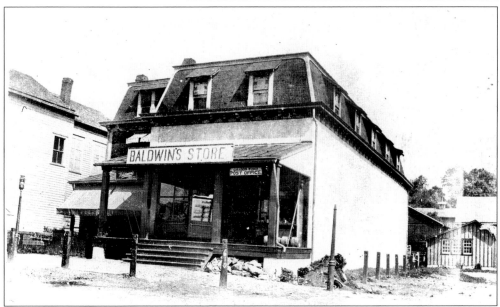

BALDWIN'S STORE AND POST OFFICE, c. 1905. Baldwin's Store was located on Route 1 in Chadds Ford, between today's Wooden Knob and the Chadds Ford Inn. The building is currently the home of an antiques store, but it has also been used as a cigar shop, dress shop, and real-estate office. At the time of this photograph, a meeting hall was on the upper floor, and family members lived in a connecting house. Nearby were a barbershop, saddlery, and tack shop.

RICHARD JACOBS BALDWIN, 1872.
Baldwin's Store was opened in 1878 by
Richard Jacobs Baldwin and his wife, Sarah
Temple Baldwin. When Richard became
interested in pursuing a career in politics, he
leased the store to his brother Henry and
later to his own son, Richard Lindley
Baldwin. In addition to owning Baldwin's
Store, Richard Jacobs Baldwin became
successful as a real-estate and insurance
agent. Politically, he held the positions of
recorder of deeds, commissioner, state
senator, and speaker of the state House of
Representatives. He also helped establish
the Pennsylvania Game Commission.
Richard died in 1944 at the age of 90.

SARAH WORRALL TEMPLE BALDWIN,
c. 1872. Sarah (Sallie) Worrall Temple was
born to Thomas B. Temple and Elizabeth
Sharpless Worrall on December 25, 1852, in
Uwchlan. Sallie married Richard Jacobs
Baldwin in 1873, and they had nine children.
Three of the children died within the first
year. Son Erskine was killed in a fireworks
factory explosion at the age of 23, and
daughter Helen was killed when hit by a train
at nearby Hamorton. (Helen was able to
throw her baby to safety, however.) Sallie's
son Richard Lindley Baldwin married local
girl Mary Wallace in 1915. Their children
were Thomas B. T. Baldwin and Wallace
Hanover Baldwin, both born in the Thomas
Wallace House on Station Way Road.

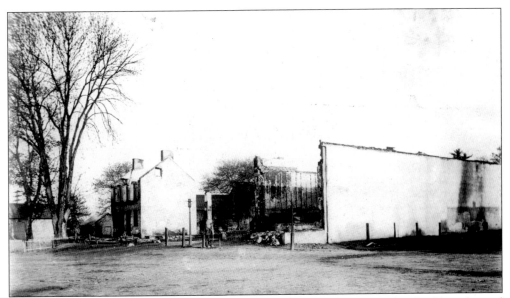

A Fire at Chadds Ford, 1915. Baldwin's Store (right) and the surrounding buildings burned to the ground on May 1, 1915. The fire started in the nearby barbershop and spread to the Arment home next-door (middle left). Damages were estimated at more than $25,000. Richard Lindley Baldwin, who lived with his mother, sister, and nephew in the house attached to Baldwin's Store, helped evacuate his family. He then darted into the post office to rescue the mail and stamps.

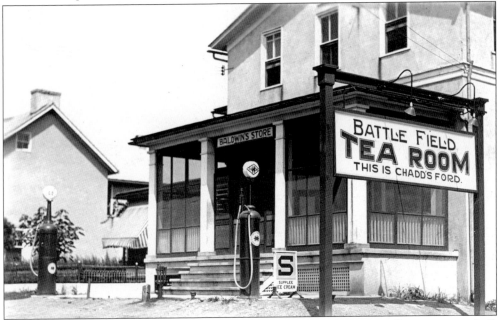

Baldwin's Store, c. 1928. The rebuilt Baldwin's Store housed the post office, a meeting hall, and a tearoom. Florence Betts Brosch, daughter of the town doctor, recalls, "[The] tea room . . . was very special when I was a little girl because when important people came to visit, we might entertain them there." One of the two fuel pumps in the photograph was probably for kerosene (used for heating and lighting homes), and the other was for gasoline.

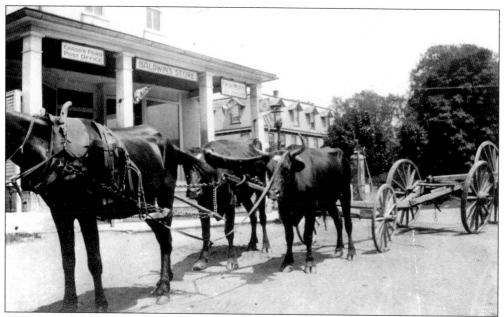

OXEN IN FRONT OF BALDWIN'S STORE, 1920. Oxen wait patiently in the middle of Route 1 while their owner conducts business in town. The Chadds Ford Hotel can be seen in the background.

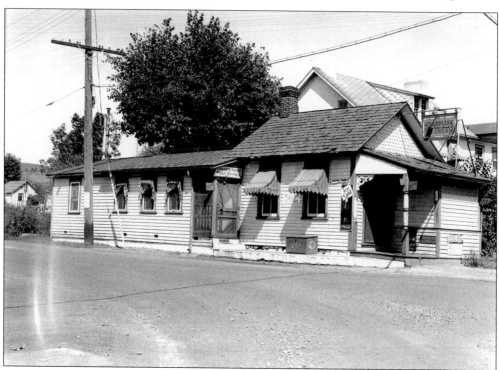

THE POST OFFICE, C. 1930. Located on the northeast corner of Routes 1 and 100, this small building housed the post office and drugstore, and has since been torn down. Druggist Dr. Green is remembered fondly for the ice cream he sold in his store. The post office was later moved to the house just west of the Gallagher General Store.

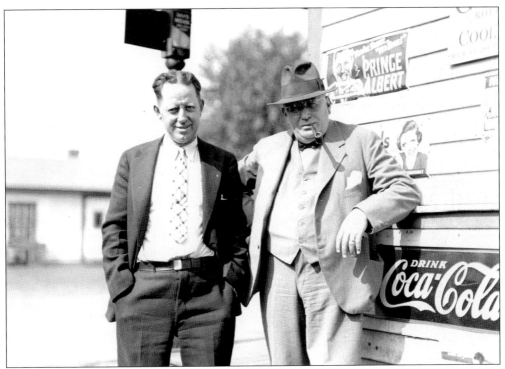

ED MILLER AND HARRY SMITH, C. 1935. W. Edwin Miller (left) and Harry Smith pose in front of Dr. Green's drugstore. Miller was a postmaster and also worked as a plumber. Smith served as the stationmaster at Chadds Ford Junction.

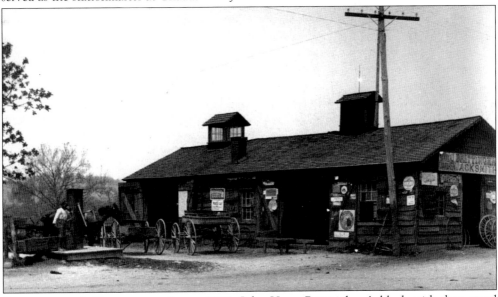

BRITTINGHAM'S BLACKSMITH SHOP, 1903. John Harry Brittingham's blacksmith shop stood on the northwest corner of Routes 1 and 100, where Hank's Place is located today. The blacksmith was among the most valued members of a community. In addition to forging horseshoes, he made farm equipment, such as axes, scythes, and plow blades; kitchen wares, such as pots and utensils; and household items, including hinges, latches, and nails.

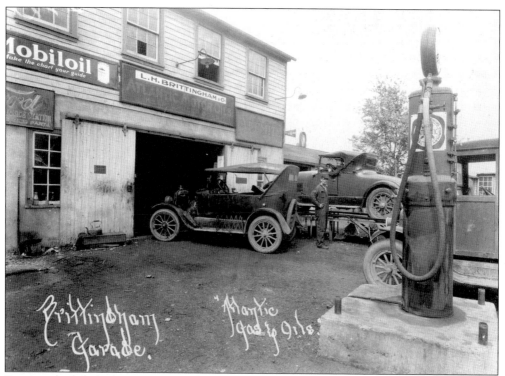

BRITTINGHAM'S GARAGE, C. 1920. John Brittingham died about 1920, leaving his widow, Lottie H. Brittingham, to run the business until her death in 1931. By this time, the blacksmith shop had been rebuilt and the corner building housed a garage as well. Resident Jean M. Oakes, whose uncle Tom Andress worked here as a mechanic, remembers when the sign at the gas tanks read five gallons for $1. (Courtesy Bernard J. Cialini.)

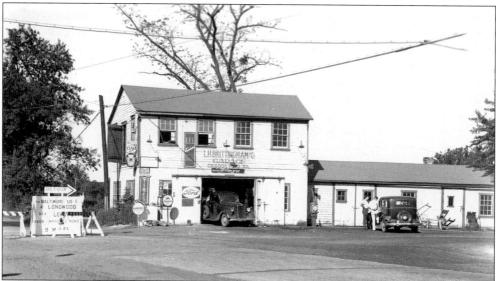

L. H. BRITTINGHAM'S GARAGE, 1937. This is a later shot of the same building. The gas tanks have been removed. The detour sign to the left directs travelers headed south on Route 1 to veer north toward Lenape and then west to Longwood to avoid road construction.

BLACKSMITH AND WHEELWRIGHT SHOPS, C. 1938. This small structure was attached to Brittingham's Garage (seen in the previous photograph). The lettering on the side of the building reads, "J. H. Brittingham / Lumber & Steam Fitter." Horace Quimby operated a wheelwright shop here. Jean M. Oakes remembers the shop when she was growing up in Chadds Ford in the 1930s. "I can still see the smithy there with the anvil. Usually there would be a horse in the blacksmith's shop being shod because it was the only shop around and of course all of the ground in the area of Chadds Ford then was farming ground."

THE GAS STATION, C. 1930. Located on the southeast corner of Station Way Road and Route 1, this gas station was owned by Horace "Tink" Quimby, who was also the proprietor of the garage across the street (seen in previous photographs).

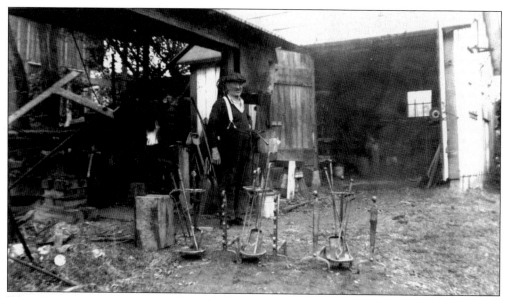

WILLARD J. SHARPLESS, C. 1930. Willard J. Sharpless rented from Horace Quimby half of the divided house that is now the Christian C. Sanderson Museum, on Route 100. Sharpless ran his blacksmithing business from a building in back of the house. A 1932 bill advertises "horse shoeing, general blacksmithing, and wheelwrighting" and "artistic wrought iron work a specialty." The $2.75 bill, charged to artist Peter Hurd, was for four shoes on a black mare. Sharpless was also notable for having a wooden leg. (Courtesy the Christian C. Sanderson Museum.)

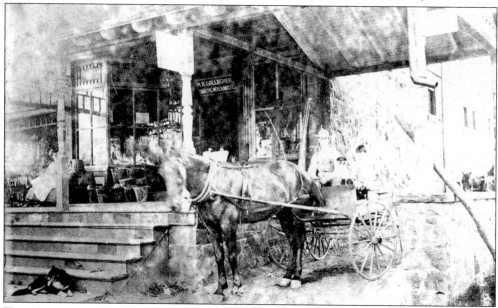

THE GALLAGHER GENERAL STORE, C. 1900. Opened in 1889, Gallagher's was located at the site of the present Leader Sunoco station, at the junction of Routes 100 and 1. Proprietor Henry "Harry" Gallagher sold food and general merchandise. Food items were sold in the front part of the store. The back of the store was tended by Georgie Riley. There, one could purchase overalls, aprons, hip boots, and bolts of cloth, among other things. Above the store was a hall where community sings and plays were held.

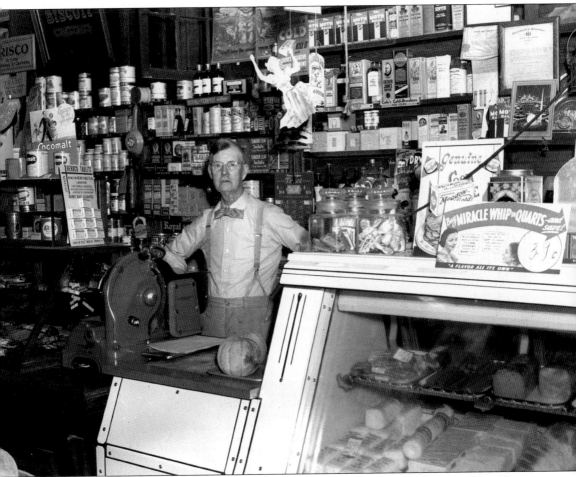

THE GALLAGHER GENERAL STORE, C. 1930. Prices were very different when Henry Gallagher operated his store in Chadds Ford. For the period between May and September 1925, he sold $100 worth of groceries to the Atwater family. Among the items purchased were bacon, bread, lemons, onions, raisins, soda, eggs, tomatoes, salmon, pineapple, sugar, and soap. Behind Gallagher in this photograph are some of the same brand names we use today, including Crisco, Miracle Whip, Tetley, and Sun Maid. Chadds Ford resident Jean M. Oakes remembers: "When you would ask for a half a pound of dried beef, Mr. Gallagher would always put it on the slicer and slice it. There was a big showcase with penny candy. If you had a nickel, you could always take six pieces."

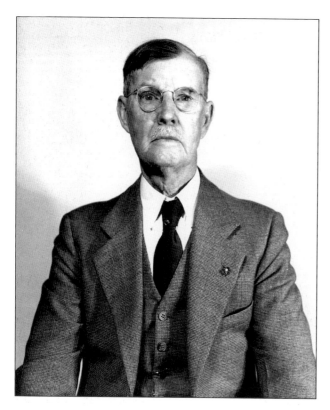

HENRY GALLAGHER, C. 1945.
In 1869 Henry (Harry) K. Gallagher was born to George C. and Phoebe H. Gallagher in Toughkenamon. Henry was proprietor of the Gallagher General Store from c. 1901 to c. 1944. After that year, he retired and moved to West Chester, where he took employment at the Mosteller department store for 18 years. He was a member of the Concord Lodge and was a trustee of Brandywine Baptist Church. Henry died on January 31, 1963, at the age of 94, and is buried in Birmingham-Lafayette Cemetery.

NELLY GALLAGHER, 1941. Nelly G. Arment was born c. 1873 to Chadds Ford wheelwright John Arment (August 6, 1830–February 14, 1889) and Elizabeth Jane Cossgrove (September 30, 1833–July 13, 1923). Nelly had six siblings: Charles, Newlin, John, Harry, Philena, and Phebe. The elder John Arment, Nelly's father, ran a successful wheelwright shop on the northwest corner of Routes 1 and 100, where Hank's Place is today; he purchased the building from Ruel Jefferis for $1,400 in 1858. Mr. Arment died at the age of 58 in a hospital for the insane. Nelly's mother lived in the house on the northeast corner of Routes 1 and 100 (where the Wooden Knob is today), and survived the fire that destroyed her home in 1915. Nelly married Henry Gallagher on April 24, 1895, and had one son, Curtis H. She died in 1941 at the age of 68.

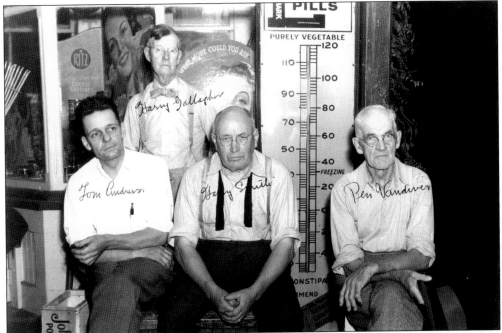

THE GALLAGHER GENERAL STORE, 1939. Three local men take a break from work to visit with Harry Gallagher (standing). From left to right are Tom Andress, mechanic at the garage where Hank's Place now stands; Harry Smith, stationmaster at Chadds Ford Junction on the west side of the Brandywine; and Pen Vandever, miller at Hoffman's Mill, today the Brandywine River Museum.

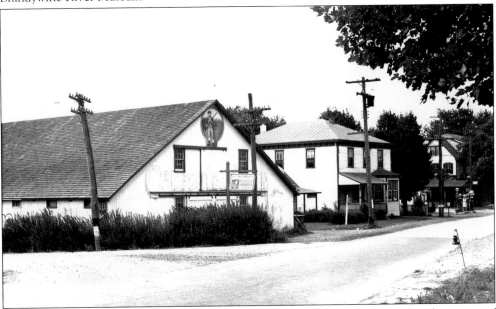

THE CERESOTA SALES BARN, C. 1930. The Ceresota Sales Barn was located at the corner of Routes 1 and 100, where the First Keystone Bank is today. The sign in front reads, "Two Miles to Hill Girt Farm." The building was used as a sales stable for weekly public auctions. The Lippincott House is to the right.

GEORGE SCUSE, C. 1930. Once a year, barber George Scuse made turtle soup for some of his friends in the village. The barbershop was located on the southeast corner of Station Way Road and Route 1, where the building that houses the First Keystone Bank, post office, and Wawa store is today. This view looks north. The Chadds Ford Inn can be seen in the background. The little girl to the left is unidentified. (Courtesy the Christian C. Sanderson Museum.)

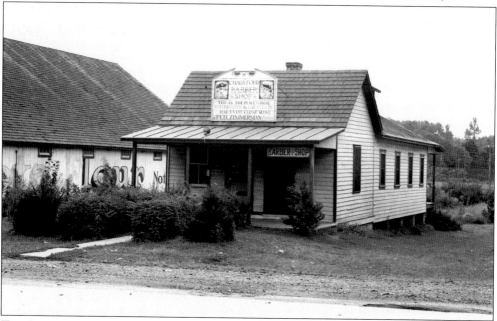

THE CHADDS FORD BARBERSHOP, C. 1930. The Oakes family of Rocky Hill Farm frequented this barbershop often. Jean M. Oakes recalls: "I remember the barber shop because my father used to take all five of us there to have our hair cut. I remember the orders my mother always gave my father about my hair, that it was to be cut bangs and the sides were to be cut so you could see the tips of my ears. My father had a shaving mug there, had his name on it like they all did."

BARBERSHOP, C. 1937. Chris Sanderson played the part of Rip Van Winkle at the Longwood Open Air Theatre in 1937. Here he hams it up for the camera with barber Pete Zimmerman, who had replaced George Scuse. The sign on the roof was painted by N. C. Wyeth. It read: "Chadds Ford Barber Shop. This is the place where Washington and Lafayette had a very close shave."

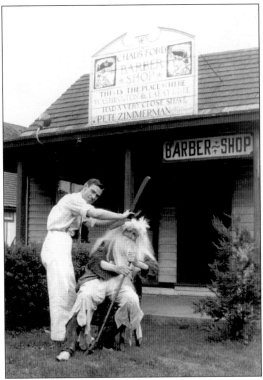

JOE PEP'S RESTAURANT, MAY 14, 1963. Several restaurants operated out of this building, located along the north side of Route 1 and several hundred yards east of Harvey Road. One of the first was Horton's Restaurant, followed by Polito's (run by Joe Pep), and then by Bell's Luncheonette (which operated from about 1963 to 1969). B&H Electric Motors occupied the building after that. The property later fell into disrepair and was torn down. (Courtesy Andy Bell.)

HERE, THE AMERICAN LIGHT INFANTRY
VIGOROUSLY RESISTED THE BRITISH.

DARIO'S, C. 1950. Dario's was located on Route 1 near Brinton's Bridge Road, where the Gables Restaurant is today. Owned by Ira J. Oakes in the 1920s and 1930s, the barn was thereafter converted to a restaurant, pharmacy, and general store run by the Dario family, who lived upstairs. Dario's sold hamburgers, sandwiches, ice cream, postcards, trinkets, balloons, and penny candy. Note the big "Elsie, the Borden Cow" on the side of the barn. This was a landmark for motorists for several decades. In the 1970s, the business changed hands and became a diner called the Country Kettle. (Courtesy Rebecca Rogers.)

CHRISTY'S RESTAURANT, C. 1950. Christy's Restaurant was located at Painters Crossing (the intersection of Routes 1 and 202), where the Sunoco station is today. This attractive restaurant served "daily dinners, lunches, a la carte, soda fountain service, choice wines and liquors" and accommodated "card parties, private banquets, and club meetings by appointment."

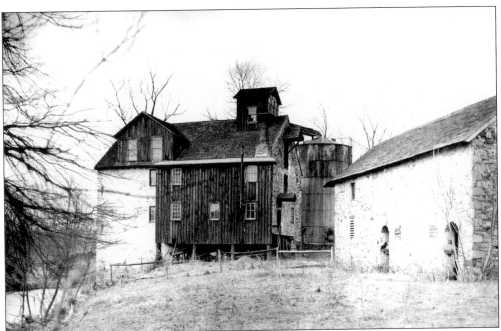

Brinton's Mill, c. 1950. Mills were plentiful in Chester County, especially along the swift-running Brandywine, and were an important part of a community's economic success. Built *c.* 1719 on Creek Road, about a mile north of Chadds Ford, Brinton's Mill was enlarged in the 1760s and was rebuilt in 1824. Mr. and Mrs. Andrew Wyeth purchased the property in the 1950s and restored both the mill and the millhouse.

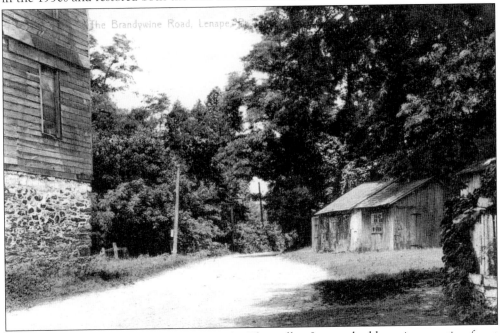

The Brandywine Road, Lenape, c. 1950. The mill at Lenape had been in operation for at least 75 years before John Sager purchased it in 1855. The lumbermill and gristmill was demolished in 1911, when the stone bridge over the Brandywine was built.

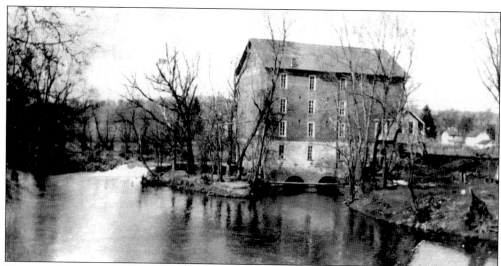

HOFFMAN'S MILL, C. 1920. Built in 1864 by George Brinton, Hoffman's Mill was strategically located along the Brandywine Creek and what is today Route 1. After changing hands several times, the mill was sold to Sellers Hoffman in 1872, and remained under Hoffman family ownership through the 1940s. By then, it was one of the few mills still in use along the Brandywine. In the late 1960s, a group of concerned local citizens banded together to form the Brandywine Conservancy and purchased the mill. In 1971, the restored mill opened to the public as the Brandywine River Museum.

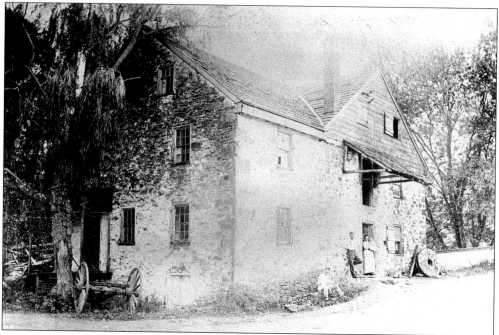

TWADDELL'S MILL, C. 1910. William Twaddell purchased land near the Big Bend on the east bank of the Brandywine Creek, just south of Chadds Ford, in 1779. From 1781 to 1807, he ran a successful sawmill and an iron forge, and later transformed the latter into a powder mill. His descendants carried on the business. Seen in this photograph are employees Mike Hanley (sitting) and Jesse Shellmeyer (with his wife and baby).

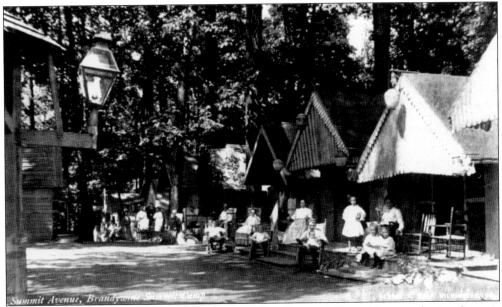

BRANDYWINE SUMMIT CAMP, C. 1900. Located in Concord Township, Brandywine Summit Camp Meeting was founded in 1867 as part of a movement to establish Methodist camp meetings across the United States after the Civil War. The camp was a summertime destination for area middle-class Methodists. At first there were between 75 and 100 tents, which were later replaced by cottages.

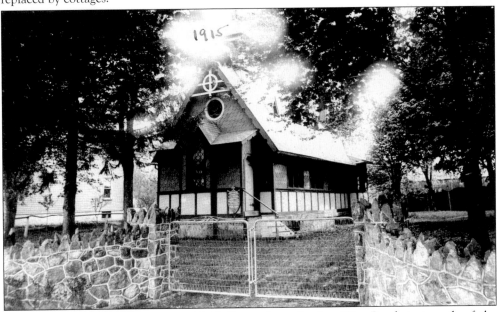

ST. LUKE'S EPISCOPAL CHURCH, 1915. Located on Station Way Road, just south of the Thomas Wallace House, this quaint building with a steeply sloped roof was built about 1885. Until 1936, it functioned as a church until the parish was dissolved by the diocese. The structure then became a private residence. Now owned by Chadds Ford Township and used as the township hall, the building has undergone several changes. The bell tower, stained-glass windows, and other exterior features have been removed.

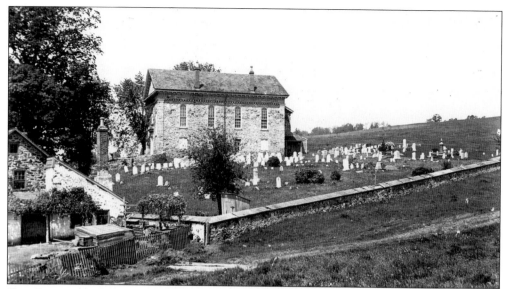

THE BRANDYWINE BAPTIST CHURCH, C. 1920. Organized in 1692, the Brandywine Baptist Church is the second-oldest congregation of its faith still active in Pennsylvania. The original log structure, built in 1718, was replaced by a stone one in 1808. The present structure was built in 1869. It is located along Route 1 near the Brandywine Battlefield.

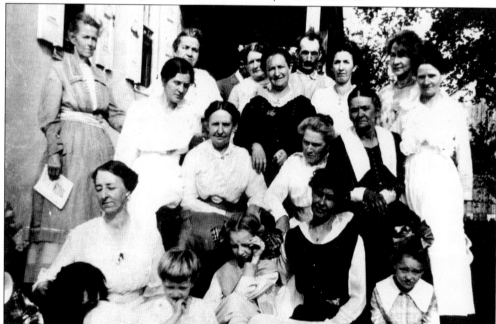

THE PHILATHEA CLASS OF THE BRANDYWINE BAPTIST CHURCH, C. 1920. *Philathea* is a Greek word meaning "lover of truth." The World Wide Philathea Union was an international organization for women, with charters issued to individual churches. Its platform was based on the following description: "Young women at work for young women with all standing by the Bible and the Bible School." The intent of Philatheans was to seek out, to study, and to live with the truth. Only two of this group have been identified: Mrs. Howard E. Seal (standing at the far left) and Letitia Talley (one of the women seated at the center).

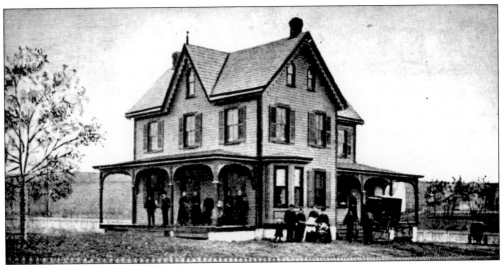

THE BRANDYWINE BAPTIST CHURCH PARSONAGE, C. 1900. The parsonage was built in 1883 at the corner of Route 1 and Heyburn Road. In 1950, the church sold the property, and the structure then became a private residence. In 1994, this Gothic Revival–style building was declared eligible for the National Register of Historic of Places. Guinta Enterprises saved the deteriorating structure when the firm purchased it in 2000 and began rehabilitation. The former parsonage is now rented as office space. (Courtesy Bernard J. Cialini.)

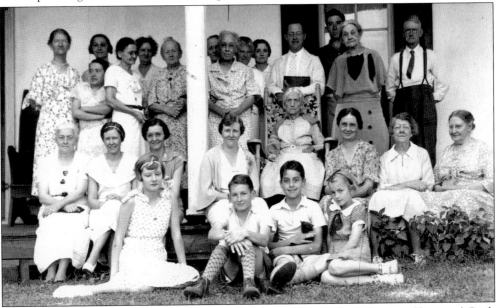

THE PHILATHEA CLASS, JULY 7, 1936. From left to right are the following: (first row) Ruth Blunt, Philip Blunt, ? Twaddell, and unidentified; (second row) ? Blanck (Mrs. Willard Sharpless), Sara Heyburn (Dunlop), Helen Brinton Heyburn (Mrs. Paul Miller), Marian Heyburn (Mrs. Bill Hoffman), Mary Twaddell, Mrs. Edward Twaddell, Nellie Gallagher, and Letitia Talley; (third row) Lena Darlington, ? Twaddell, Emma Arment, Alice Arment, Grace Wicks, Annie Wallace (Mrs. Thomas Wallace), Margaret Heyburn (Mrs. Isaiah Heyburn), Mary Emma Seal, Mamie Hoffman (Mrs. William Hoffman), Mrs. Myrtle Blunt, Rev. Bruce K. Blunt, ? Twaddell, Josephine Talley, and Mrs. Twaddell's father (name unknown).

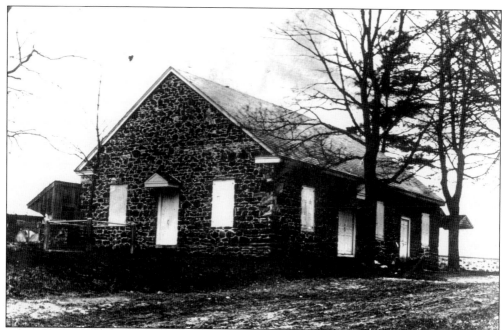

BIRMINGHAM FRIENDS MEETING, C. 1920. Birmingham Friends Meeting was founded in 1690. The first meetings were held in the home of William Brinton, an early settler. In 1722, the congregation built a cedar-log meetinghouse, which was replaced by a stone building in 1763. Before and after the Battle of Brandywine, the meetinghouse was used as a hospital by American and British soldiers, respectively.

MOTHER ARCHIE'S CHURCH, C. 1930. This eight-sided stone schoolhouse was built about 1838 at the corner of Bullock and Ring Roads. The building was purchased by Lydia Archie in 1891. She established an African Union church and served as the preacher, and lived in a house nearby until her death in 1932. Today, Chadds Ford Township owns and maintains the ruins of the two buildings and the cemetery.

Three
AROUND TOWN

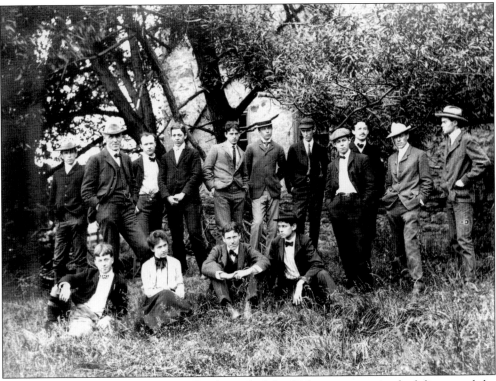

HOWARD PYLE'S STUDENTS, 1903. By the end of the 19th century, artists had discovered the beauty and history of Chadds Ford. In 1898, Howard Pyle, a noted illustrator, started a summer art school in the old Turner gristmill, just across the road from the Benjamin Ring House (Washington's Headquarters). Many artists were attracted to this school, including Frank Schoonover, N. C. Wyeth, Violet Oakley, Sarah Stilwell, and Maxfield Parrish. Here, the 1903 class poses for the camera. From left to right are the following: (first row) William Aylward, Anna Whelen Betts, Gordon McCouch, and Henry Peck; (second row) Alan True, Howard Pyle, Arthur Becher, Harry Townsend, Clifford Ashley, Francis Newton, George Harding, Frank Schoonover, Ernest Cross, Walter Whitehead, and Thornton Oakley.

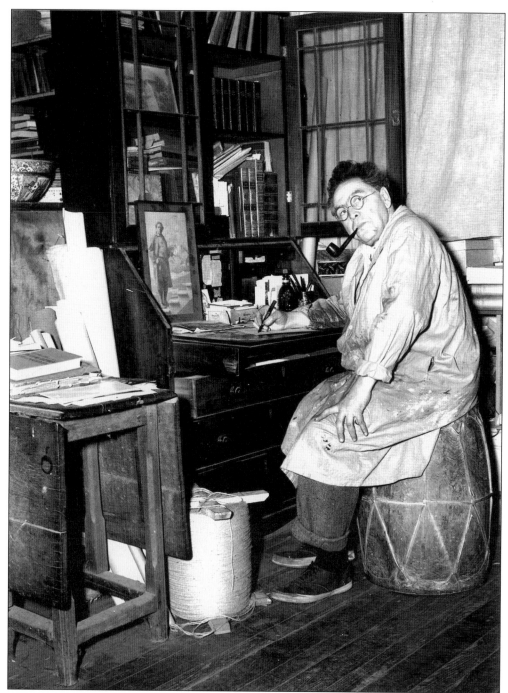

N. C. Wyeth, October 27, 1939. Newell Convers Wyeth came from Massachusetts to Wilmington in 1902 to study with artist Howard Pyle. After spending the following summer attending Pyle's summer session in Chadds Ford, Wyeth decided to settle in the town, where today his children and grandchildren carry on his artistic legacy. Four of Wyeth's five children were painters—Henriette, Carolyn, Ann, and Andrew—and several of his grandchildren continue the tradition.

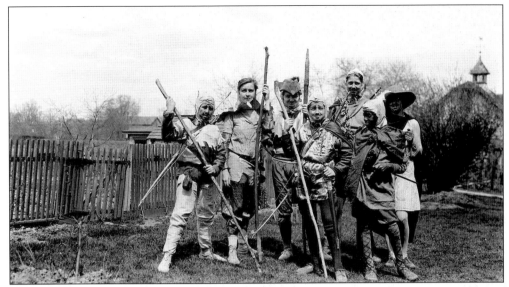

ROBIN HOOD'S GANG, C. 1930. Seven Chadds Ford children, who are dressed as members of Robin Hood's gang, take a moment from playacting to pose for the camera. From left to right are Harry "Buddy" Arment as Little John, Mary Sargent as Allan-a-Dale, Ann Wyeth as Will Scarlet, Andrew Wyeth as Robin Hood, William Seal as a bowman, David "Doo Doo" Lawrence as Friar Tuck, and Betty Seal as another bowman.

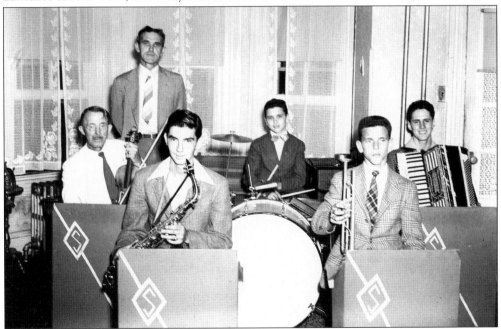

THE POCOPSON VALLEY BOYS, C. 1935. Chris Sanderson formed the Pocopson Valley Boys in 1932. The group played for broadcasts over WDEL in the barn dance portion of Sanderson's regularly scheduled program, *Old Folks at Home*. The band members changed over the years, but in this photograph, they are Chris Sanderson on fiddle, an unidentified boy on saxophone, Jack Oakes on drums, Lane Oakes on trumpet, and an unidentified boy on accordion. Standing in the back is Lane Oakes Sr., who provided the transportation.

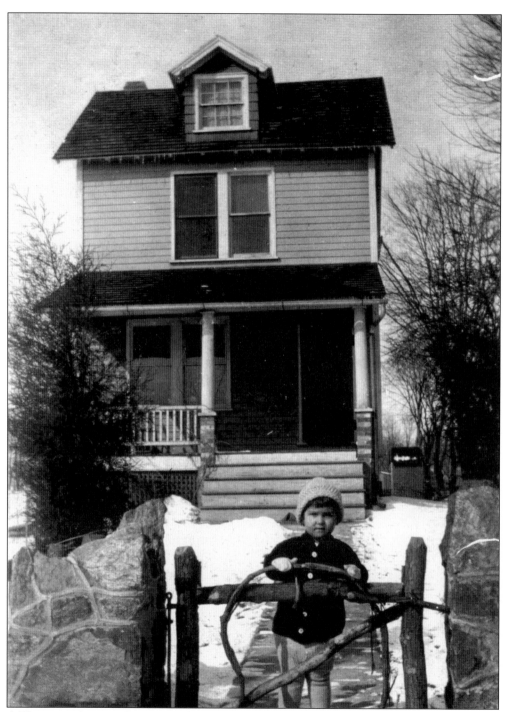

A House in Chadds Ford, c. 1920. An unidentified young boy has come out to play in the snow in this early-1900s photograph. This home is located just south of the current Chadds Ford township building on Station Way Road in Chadds Ford. The property was owned by members of the Arment family for at least a 40-year span from about the 1890s through the 1930s, and perhaps for longer. Since 1978, the house has been owned by the Razze family.

MARGARET PRICE, C. 1903. Margaret Price, daughter of Dennie and Emma Price, wears her best frock to pose for this portrait. The Price family lived at the Chadds Ford Hotel for a time in the early 1900s.

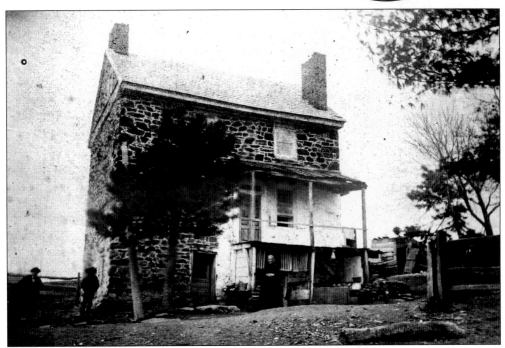

THE JOHN CHADS HOUSE, C. 1910. Built *c.* 1725 by Quaker farmer and businessman John Chads, this charming stone building was home to John and his wife, Elizabeth, from their the time of their marriage in 1729 until John's death in 1760. Elizabeth lived 30 more years in the house, and even refused to evacuate while the Battle of Brandywine raged around her. The house fell into disrepair in the 20th century but saw new life in 1968, when the Chadds Ford Historical Society purchased and restored it as a historic house museum.

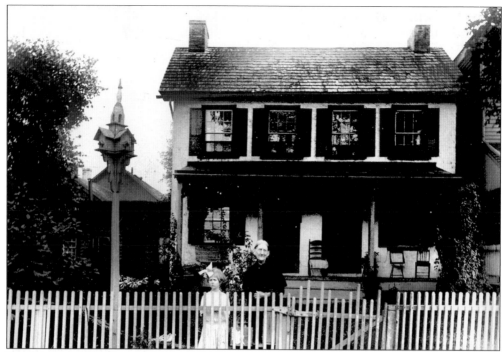

THE ARMENT HOUSE, C. 1910. Elizabeth Jane Arment (later McCord) and her great-grandmother, Elizabeth Jane Cossgrove Arment, widow of wheelwright John Arment, pose in front of their home at the intersection of Routes 1 and 100, where the Wooden Knob store is today.

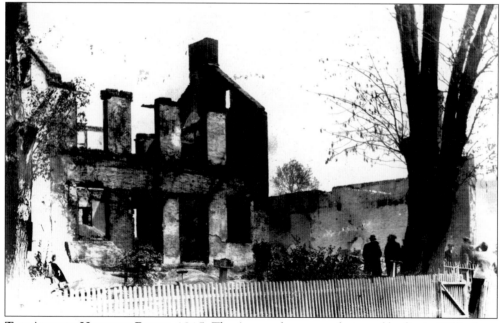

THE ARMENT HOUSE IN RUINS, 1915. The Arment house was destroyed by fire in 1915, along with Baldwin's Store next-door. Newspapers reported that, in a daring rescue, the unconscious Elizabeth Jane Arment was taken from her burning home while firefighters battled the blaze in a three-hour fight. The fire caused a total of $25,000 worth of damage.

MARY DILWORTH, 1947. Ed Seal composed this portrait of Mary Dilworth on August 21, 1947, on the occasion of her 100th birthday. She lived for four more years. The widow of Tom Dilworth, Mary lived across from the Seals on Station Way Road in the brick house where Gentry's Tack Shop is today. At that time, the house was divided into two residences, and she occupied the southern part. (The Vandevers lived in the northern half.) Mary is remembered as a very ladylike and proper woman. Her brother, Harry Pyle, ran one of Chadds Ford's largest businesses: a lumberyard, building, and farm-supply store.

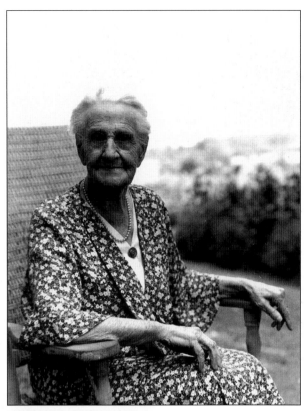

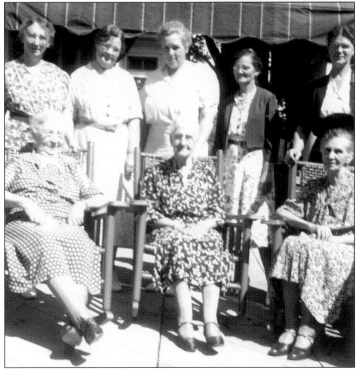

A GROUP PORTRAIT, c. 1947. Only a few of these women have been identified. Mary Dilworth is seated in the center, with Stella Pyle (wife of Harlan Pyle) standing directly behind her, and Mrs. Harry Arment to the right of Stella Pyle. (It appears flower-print dresses were in fashion.)

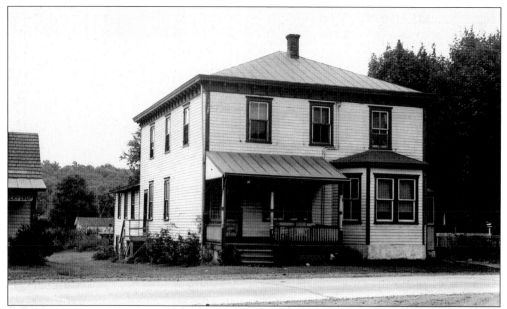

THE LIPPINCOTT HOUSE, C. 1930. The Lippincott family lived in this house at the southeast corner of Station Way Road and Route 1, where the Wawa stands today. Fred Lippincott worked as the miller at the Chadds Ford Mill (also called Hoffman's Mill and, later, the Brandywine River Museum). In 1929, Fred Lippincott went to work at the Brinton's Bridge mill, and his family moved nearby.

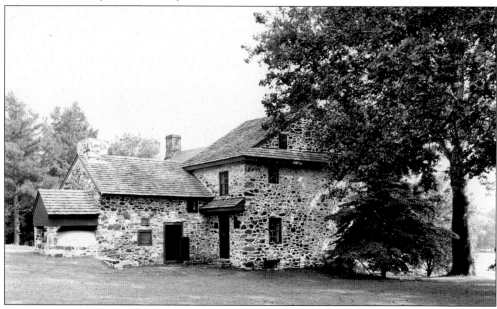

THE GIDEON GILPIN HOUSE, C. 1955. Built in 1745, this house was owned by Quaker farmer Gideon Gilpin at the time of the Battle of Brandywine. When the American army retreated, area properties were plundered by British soldiers. Gilpin's losses totalled £502 and included items such as 10 cows, 48 sheep, 28 swine, 12 tons of hay, 230 bushels of wheat, 100 bushels of potatoes, a looking glass, a clock, a history book, and one gun. In the 20th century, the house was owned by the Cleveland family. Today, it is part of the Brandywine Battlefield Park.

ELIZABETH JEFFREYS GUSS, C. 1910. Quaker sisters Elizabeth Jeffreys Guss and Anna Jeffreys lived in the western half of the divided Benjamin Ring House (Washington's Headquarters). By 1907, they had become friends of N. C. Wyeth, who thought of them as grandmothers. Wyeth described Elizabeth as "interesting and quaint" and thought the following letter she wrote in 1908 characteristic of her. "Dear Esther—We will be at home on Saturday. Come if thee can but leave thy headache at home. As ever thy friend Elizabeth. Fourth day 10th month."

CHRIS SANDERSON AND MOTHER, 1942. Christian Carmack Sanderson (1882–1966) moved to Chadds Ford in 1905 for a teaching job, and quickly came to feel at home in the town. He is remembered as a colorful character who never owned a car but hitchhiked his way around. In 1906, he and his mother moved into the eastern portion of the Benjamin Ring House (Washington's Headquarters), where they lived until 1922. Later, they rented a home on Creek Road that became the Christian C. Sanderson Museum in the 1960s.

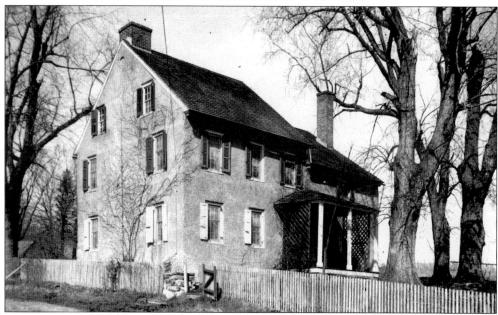

THE BENJAMIN RING HOUSE (WASHINGTON'S HEADQUARTERS), C. 1920. Built *c.* 1720, this stone house was owned by farmer and miller Benjamin Ring, a prominent Birmingham Township Quaker. During the Battle of Brandywine on September 11, 1777, Gen. George Washington and his officers made their headquarters here. Their effort to halt the British army's advance toward Philadelphia failed, and American troops were forced to retreat toward Chester.

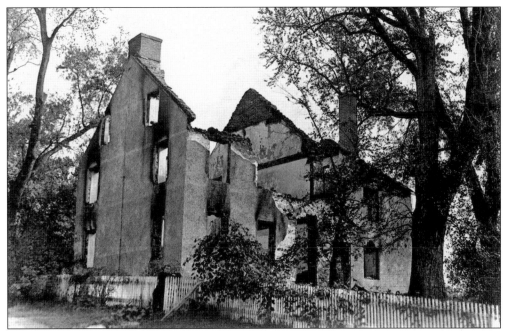

THE BENJAMIN RING HOUSE, 1931. A barking dog woke Helen DuBois in the early-morning hours of September 16, 1931. A fire was blazing in the kitchen of the Benjamin Ring House, where Helen had operated a teahouse for two years. Neighbors worked together to contain the flames, but the house was completely consumed.

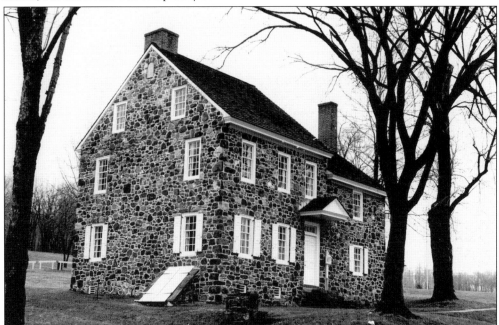

THE BENJAMIN RING HOUSE, C. 1950. In 1949, the state of Pennsylvania created the 50-acre Brandywine Battlefield Park, which included the Benjamin Ring House and the Gideon Gilpin House. Both homes were restored to their 18th-century appearance and appointments. Today, visitors tour the park to learn about the battle and its effect on area residents.

WILLIAM E. MILLER, C. 1935.
William Edwin Miller was a farmer
and mailman who lived one house
north of the residence that is today the
Christian C. Sanderson Museum. He
was married twice—first to Martha
Trimble, who died at a young age, and
then to Martha Burnett. He had four
children: W. Edwin, Paul G., Bessie,
and Nellie. Mr. Miller died in 1942.

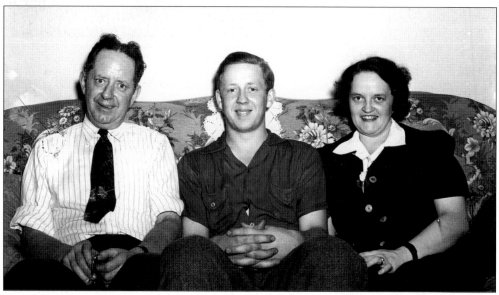

THE MILLERS, 1942. W. Edwin Miller (left) was the son of William E. Miller (previous photograph). He and his first wife, Marian R. Miller, had two children: Bill (center) and Janet. Marian served as postmaster in Chadds Ford from May 1, 1926, until her death in 1929. Thereafter, Ed took over as acting postmaster, and was followed by J. Horace Quimby (appointed on August 17, 1929) in the same capacity. Miller was appointed postmaster on March 17, 1930. He resigned in 1943 and was succeeded as postmaster by his second wife, Mildred Vandever Miller (right). Ed was also a plumbing and heating contractor. He died in 1948 and is buried in Birmingham Cemetery.

**WILLIAM E. ("BILL") MILLER,
1942.** Bill Miller was the son of
W. Edwin and Marian Miller. Both
of Bill's parents had served as
postmaster at one time, and he
followed in their footsteps.

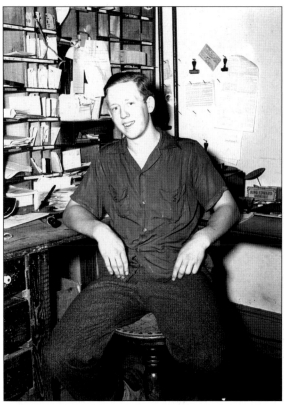

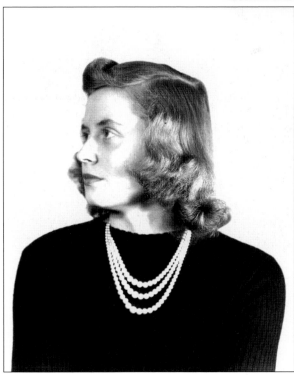

JANET MILLER, C. 1935. Janet
Miller was the daughter of
W. Edwin and Marian Miller.
Born c. 1920, she attended the
Chadds Ford Consolidated
School, and is remembered by her
classmates as a popular and
talented girl who played piano.
Janet and her father made the
local news on October 21, 1938,
after an attempted robbery of
their general store and post office:
Janet was disturbed at 5:00 a.m.
by a noise in the rooms below
their living quarters and rose to
wake her father. He grabbed his
shotgun and leaned out the
window to see two men climbing
through a lower window. Miller
shot one burglar in the legs and
held the other at gunpoint until
the police, coming all the way
from Media, arrived.

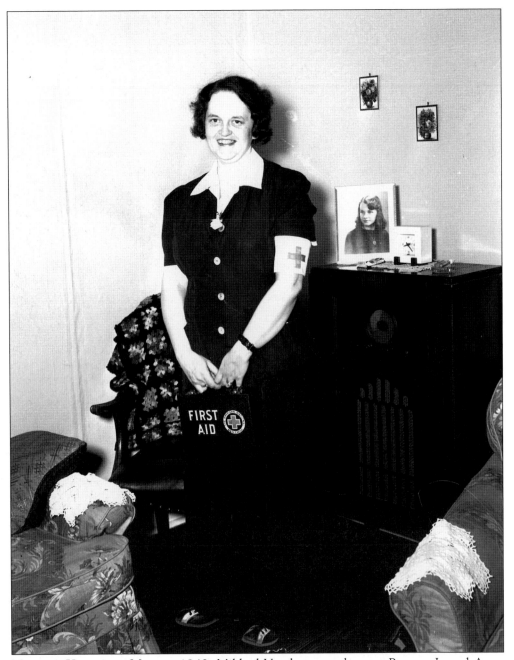

MILDRED VANDEVER MILLER, 1942. Mildred Vandever was born to Penrose L. and Anna (Burke) Vandever on December 13, 1909, in Lebanon, Pennsylvania. When Mildred was young, her father moved the family to the Chadds Ford area to work at the Chadds Ford Mill (also called the Hoffman Mill and today the Brandywine River Museum). Mildred married W. Edwin Miller in 1931. After her husband resigned from his job as Chadds Ford postmaster in 1943, Mildred was appointed to the position. Here she wears a Red Cross armband and holds a first-aid kit.

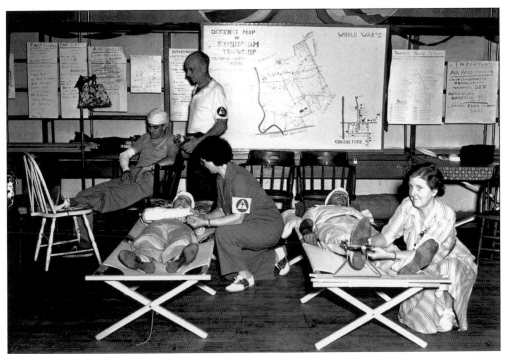

AN AIR-RAID DRILL, C. 1940. In May 1942, Chadds Ford residents formed the Birmingham Defense Council. Members attended aircraft-recognition school (taught by Chris Sanderson), appointed air-raid wardens, organized scrap drives, and offered classes in first aid and firefighting.

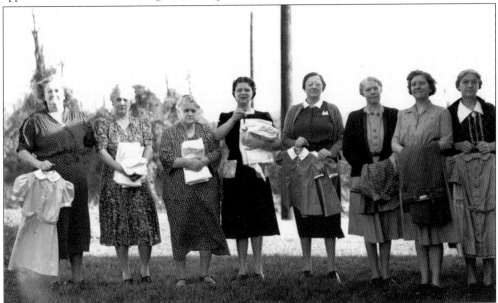

THE CHADDS FORD NEEDLEWORK GUILD, C. 1940. Even though Chadds Ford was a small village, its residents were active in many civic activities. In addition to the Chadds Ford Needlework Guild (shown here), there was also a sewing club and a crochet club. In this view, Mrs. Delmont Broadbelt is third from the left. Fourth from left is Mrs. Harry Pyle, and fifth from the left is Estelle Pyle. The others are unidentified.

MR. AND MRS. HARLAN PYLE, 1941. Harlan and Estelle Pyle lived for a time next-door to the Gallagher General Store, in a house now owned by the Brandywine Conservancy. They then moved to a brick house called Green's Headquarters, on a hill along Baltimore Pike east of the Guest house (Chadds Ford Gallery today). The couple had twin daughters, Mary and Alice.

WINDTRYST, C. 1890. The majestic Windtryst, built in 1867 by Mr. and Mrs. Joseph C. Turner, stood along Route 1, high above the Benjamin Ring House. The Turners owned large parcels of land along both sides of Route 1, including Turner's Mill, where Howard Pyle ran his summer art school, and Lafayette Farm, which Pyle rented as living quarters. Pyle's students rented rooms in both the Gilpin and Ring houses.

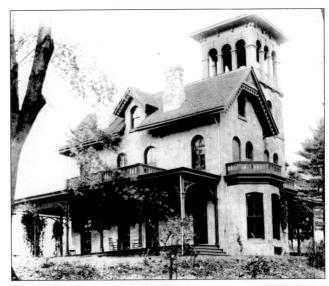

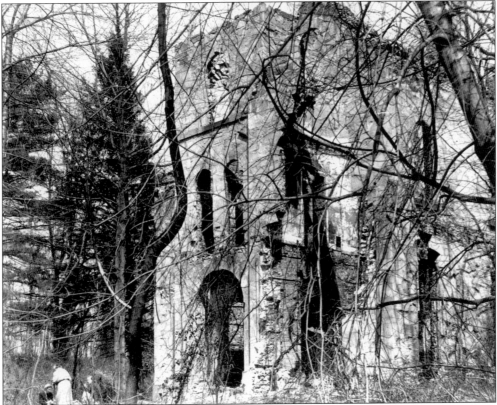

WINDTRYST, 1945. Windtryst burned on September 11, 1914, in a fire thought to have originated from a fireplace spark igniting the shingle roof. A local newspaper article estimated $20,000 in damages. At the time, the serpentine stone house was owned by Richard Mead Atwater and was leased to Mrs. Florence Passmore (daughter of Richard Jacobs Baldwin), who operated it as a boardinghouse. Windtryst was never rebuilt; however, a barn on the property has been converted to a private home.

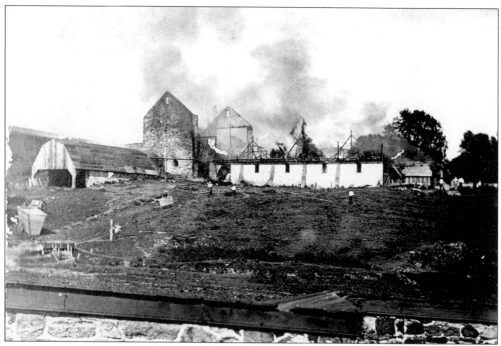

The Cleveland Barn, 1905. Dr. Arthur Cleveland, a ward of Joseph and Eliza Turner during his youth, lived at the Red Barns farm (today known as the Kuerner Farm) from 1903 to 1906. In 1906, after the Turners had died, Cleveland purchased their Lafayette Farms property. He then sold a majority interest to his father-in-law, Richard Atwater, with whom he ran the estate. The barn in this photograph was destroyed by fire on August 5, 1905.

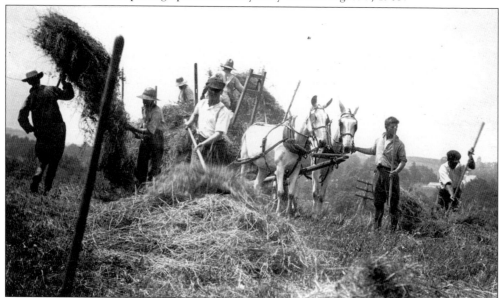

Haying at Lafayette Farm, 1917. Seven young men recruited from the University of Pennsylvania by Dr. Arthur Cleveland help bring in the summer's crop of hay. Using pitchforks, they lift the hay onto a wagon pulled by two white mules. This photograph was probably taken by Chris Sanderson. (Courtesy the Christian C. Sanderson Museum.)

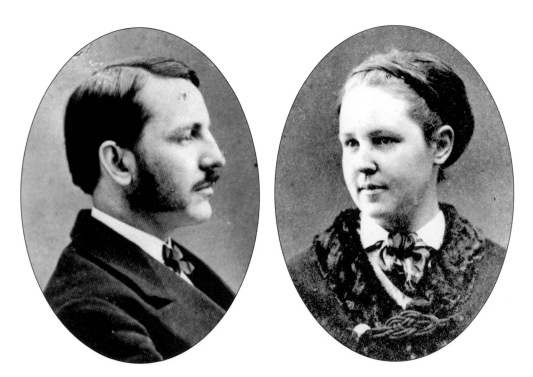

LEFT: RICHARD MEAD ATWATER, 1867. *RIGHT:* ABBY SOPHIA GREENE, 1867. Richard Mead Atwater and Abby Sophia Greene were married in 1867 in Providence, Rhode Island, before settling in Millville, New Jersey. In 1889, the family moved to Germantown, Pennsylvania, where Richard worked for a glassworks company. A year later, he took a leave of absence to study glass-manufacture methods in Berlin, Germany. He then moved his family first to Syracuse, New York, and later to Paris for many years, before settling in Chadds Ford in 1906. There, Abby and Richard purchased an interest in Lafayette Farm, and brought with them 109 packing cases containing furniture, books, clothing, and household items they had amassed during their six-year European sojourn. Nearby was the Red Barns property (Kuerner Farm), then owned by the Atwaters' son-in-law, Dr. Arthur Cleveland. After the death of Arthur's wife, Ethelwyn, her sister Sophia took over the care of the two Cleveland children.

RICHARD MEAD ATWATER AT LAFAYETTE HALL, 1916. After moving to Chadds Ford, Richard Mead Atwater found country life tedious at first, and spent much of his time in his well-stocked library containing several thousand classics in different languages. Gradually, however, he developed an interest in the "chemical and physical problems of agriculture and horticulture." This interest propelled Atwater into the operation of an orchard and dairy farm. In this photograph Atwater stands on the freshly paved Route 1 in front of Lafayette Hall. Built *c.* 1857 by Samuel Painter, this three-story home with cupola is located on Route 1 just east of the Gideon Gilpin House. In the late 1800s, Joseph Turner leased this house and the nearby gristmill to Howard Pyle for use as a summer residence and art studio. In 1906, Richard and Abby Atwater purchased the house and 48 surrounding acres. The residence was later occupied by members of the Atwater and Cleveland families through the 1950s. Still standing today, the house is nicknamed "Painter's Folly."

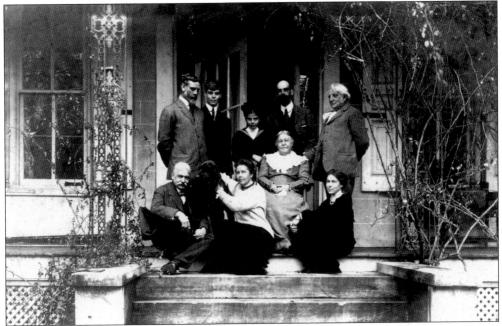

ATWATER FAMILY AND FRIENDS, C. 1912. Atwater family members pose on the porch of their Lafayette Farm house. From left to right are the following: (first row) Will Greene, Sophia Mead Atwater (first of nine children of Richard and Abby Atwater), Abbey Sophia Greene Atwater, and Helen Mason Gross (an art student); (second row) Prescott Clarke (a relative of Abby), Arthur Horton Cleveland Jr. ("Punch"), Ethelwyn M. Cleveland ("Blossom"), Dr. Arthur Horton Cleveland, and Richard Mead Atwater. The Irish setter is named Vidock.

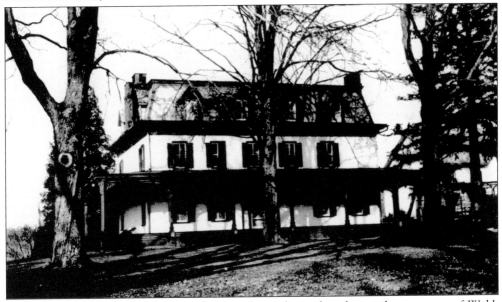

BRANDYWINE GLEN, C. 1950. Brandywine Glen is located at the northeast corner of Webb Road and Route 1. In the 1880s contractor William Arment remodeled the residence to incorporate the property's original structure, which reportedly was used as a hospital during the Battle of Brandywine. The house stayed in the Scheidt family for close to 100 years.

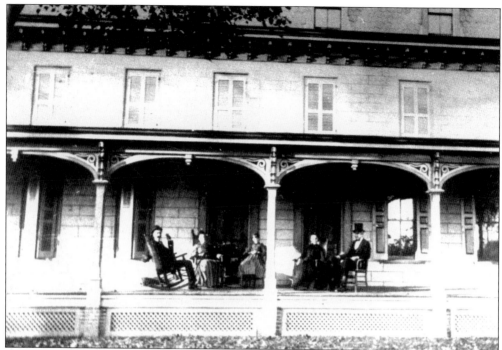

THE HOME AT CHADDS FORD, 1887. Here, the Scheidt family gathers for a group portrait on the porch of their Brandywine Glen home. From left to right are Gottlieb Scheidt; Mary A. Scheidt House and her 10-year-old daughter, Margaret S. House; Annie K. Scheidt; and John D. Scheidt.

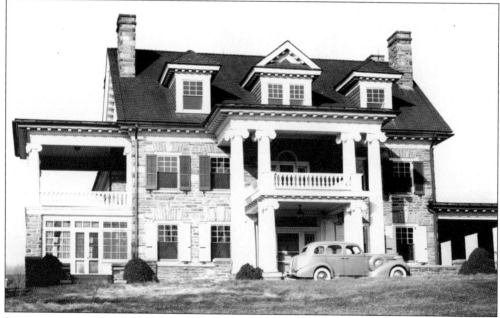

STONEBRIDGE, C. 1935. Built by John Scheidt in the early 1900s, this stone Georgian Revival house still stands at the northwest corner of Webb Road and Route 1. John's father, Gottlieb Scheidt, bequeathed him the house across the street, Brandywine Glen, which he in turn gave to his sister Mary Scheidt House.

MRS. SELLERS HOFFMAN JR., C. 1935.
The Hoffman family owned the mills at
Chadds Ford and Brinton's Bridge for over
80 years. In the 1870s, Sellers Hoffman
Sr. purchased the Brinton Mill and the
Edward Brinton House, and then bought
several other Birmingham Township
properties, accumulating close to 600
acres in total. After his death in 1893,
Hoffman willed the mill and farm at
Brinton's Bridge to his son William and
the flour mill at Chadds Ford to his son
and namesake, Sellers Hoffman Jr. The
woman pictured is the wife of Sellers Jr.

**PORTRAIT OF AN UNIDENTIFIED
MAN, C. 1940.** This man's identity is
not known, but he is thought to be a
member of the Hoffman family.

MR. AND MRS. HOWARD HOFFMAN, C. 1935. Howard and Margaret Oakes Hoffman are remembered as great golfers who liked to travel. Margaret played the piano and worked at the Pyle and Sons warehouse as the bookkeeper. Howard and his brother William were descendants of Sellers Hoffman, who owned the Chadds Ford and Brinton's Mills.

THE ARMOR HOUSE, C. 1935. Walter Armor lived in this house located on Route 100 just south of Route 1, near the sharp westward curve. Armor's neighbors included Howard Seal, Mary Emma Seal, and John and Hannah McVey.

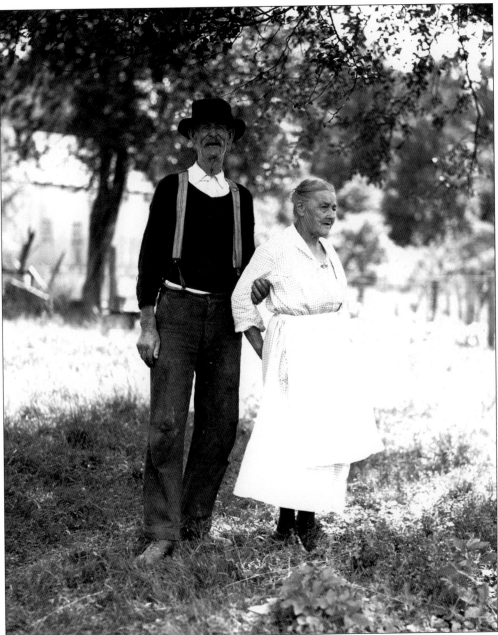

MR. AND MRS. JOHN MCVEY, C. 1930. John H. McVey (1853–1939) and Hannah E. Tyson McVey (1853–1938) lived in the house on Route 100 south of Chadds Ford near the N. C. Wyeth studio, where the road takes its first sharp turn to the west. The six-foot six-inch John McVey farmed 31 acres, raised honeybees, and hunted raccoons. Hannah is described in her obituary as a "woman of quiet disposition" who had many friends, and who, when her health permitted, attended the Brandywine Baptist Church. John and Hannah had no children but they raised a niece named "Birdie" Becker. The McVeys are buried in Union Hill Cemetery in Kennett Square.

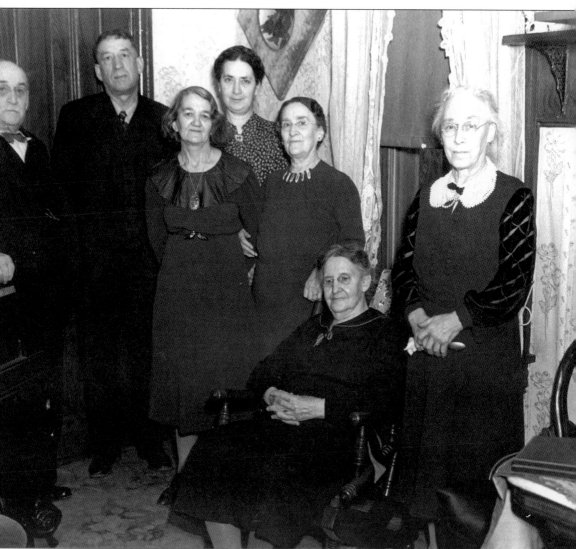

A Group Portrait, 1939. From left to right are Howard E. Seal, Edward Twaddell, Bessie Talley Courtney, Nettie Twaddell, Cornelia Watkin Johnson, Letitia Talley (seated), and Mary Emma Seal. Cornelia Watkin was the daughter of Mary Twaddell (seen in the next photograph) and Caleb Ring Watkin. Cornelia was born in 1872 and had six siblings. She married William Johnson, who farmed a plot of land at Johnson's Corner (Beaver Valley Road and Route 202) in Concord Township. Cornelia was a schoolteacher at the Johnson's Corner School.

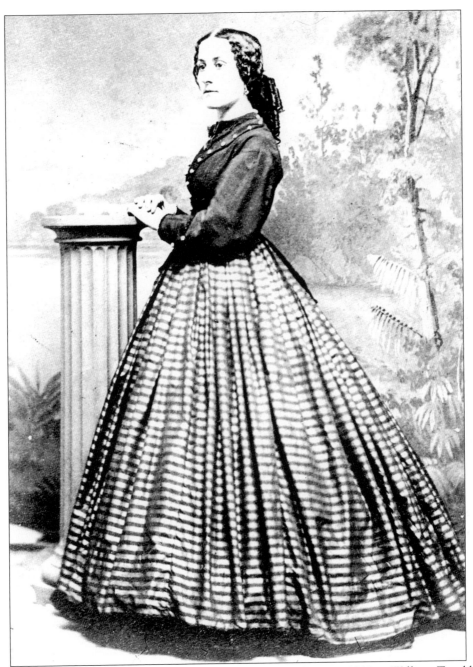

MARY TWADDELL WATKIN, C. 1865. Mary Twaddell was born in 1840 to William Twaddell (born c. 1810) and Catherine Horter. Mary married Caleb Ring Watkin (1833–1888), son of Isaac Watkin, Chadds Ford's first postmaster. Caleb served as a second lieutenant in the 70th Pennsylvania Regiment during the Civil War. The couple had seven children: Isaac, Catherine, Emma, Cornelia, William, Mary, and Nathaniel Ring Watkin. The family lived on Beaver Valley Road in Concord Township, Delaware County. Caleb died at the age of 55, leaving Mary to live off his pension while raising the children. Mary and Caleb are both buried at Brandywine Baptist Church Cemetery.

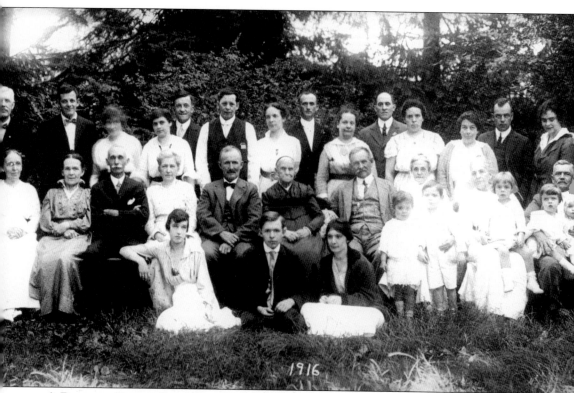

1916

A BALDWIN FAMILY REUNION, 1916. From left to right are the following: (first row—adults seated on grass) Edith Connard, John Fisher, and Mary Fisher; (second row—young children) Sarah Baldwin Temple, Richard E. Passmore, Betty Burr Hoffman, Vernon Hoffman Jr., and Mary Louise Hoffman; (third row) Lizzie Baldwin Fisher, Phoebe Baldwin Connard, Bayard Connard, Anna Mary Baldwin, Henry C. Baldwin, Mary Baldwin, Richard J. Baldwin, Sarah Temple Baldwin, Hannah Baldwin Hoffman, and George Hoffman; (fourth row) George Fisher, Richard Lindley Baldwin, Mary Wallace Baldwin, Gertrude Baldwin, George Baldwin, Thomas Baldwin, Carrie Connard Krauser, ? Krauser, Mary Temple, William P. Temple, Florence Baldwin Passmore, Mary Hoffman, Vernon Hoffman, and Louise Hoffman. (Courtesy Thomas B. T. Baldwin.)

RICHARD LINDLEY BALDWIN, C. 1915. Born in 1887, the son of store owners Richard and Sarah Baldwin, "Lin" married local girl Mary Wallace in 1915. The couple had two children: Thomas B. T. Baldwin and Wallace Hanover Baldwin, both born in the Thomas Wallace House on Station Way Road. Lin died in 1951. (Courtesy Thomas B. T. Baldwin.)

THE THOMAS WALLACE FAMILY OF CHADDS FORD, C. 1919. Members of the Wallace and Baldwin families are shown at a picnic beside the Brandywine River behind the Wallace home, on Station Way Road (just south of Route 1). From left to right are the following (first row) Arthur P. Wallace, Helen Way Wallace, an unidentified cousin from Ohio with a child, and Mary Wallace Baldwin; (second row) unidentified, Annie L. Wallace, T. Lewis Wallace, Elsie McKinley Wallace, Thomas Wallace, Ralph S. Wallace, Emily Wallace, and Richard Lindley Baldwin. (Courtesy Thomas B. T. Baldwin.)

THOMAS WALLACE AND ANNIE LAFFERTY, c. 1920. Thomas Wallace and Annie Lafferty Wallace lived on Station Way Road in Chadds Ford from 1887 to 1927. Thomas was the station agent for the railroad, selling tickets and handling freight. He also performed postmaster duties during the years when citizens picked up their mail at the train station. Mr. Wallace served on the local school board and was a deacon in his church as well.

THE THOMAS WALLACE HOUSE, c. 1927. The Thomas Wallace House is located on Station Way Road just north of the current township building. Built probably in the 1880s, the house was first owned by a Dr. H. Hayward. It was soon sold to Thomas and Annie Wallace, who had five children and lived there until 1927. The residence then became home to William Seal and family until 1944. This house was recently purchased by the Brandywine Conservancy, and is being restored for use as residential or office space.

THE SUMMONS SISTERS, C. 1860. From left to right are Averilla Summons (Darlington), Mary Jane Summons (Mrs. William Shimer), and Laura Summons (Bloom). Mary Jane Summons was Howard Ellsworth Seal's mother-in-law. Her daughter Annie Lincoln Shimer married Seal in 1886. Mary Jane also had a son, Edward J. Shimer. The Shimers lived on a 138-acre farm in Chadds Ford. In addition to the more typical crops of corn and hay, William Shimer grew Niagara grapes, which he sold to West Chester retailers for 7¢ or 8¢ a pound.

HOWARD ELLSWORTH SEAL SR., C. 1935. Born c. 1850 to William Heyburn Seal and Deborah Twaddell Seal of Birmingham Township, Howard Ellsworth Seal was a member of the Birmingham School Board. He married Annie L. Shimer (1864–1920) in 1886. Their surviving children were Eva May, William Howard, Edward J. Shimer, and Howard Ellsworth Jr. Howard Sr. died in 1940 at the age of 82. He owned Locust Knoll Farm until 1929, when he sold the farm and moved into town.

THE HOWARD SEAL HOUSE, C. 1940. After retiring from farming and selling his Locust Knoll estate in 1929, Howard Seal Sr. purchased this 1850s house on Route 100 just south of Route 1. His younger sister, Mary Emma Seal, and his adult son, Edward J. S. Seal, lived with him.

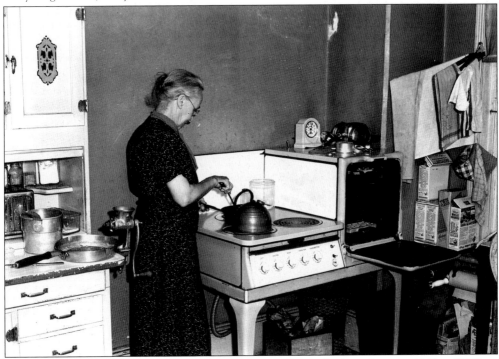

MARY EMMA SEAL IN THE KITCHEN, C. 1930. Mary Emma Seal was born in 1865 to William Heyburn Seal and Deborah Twaddell Seal. She never married but lived with her parents at the family farm, Locust Knoll, until after their deaths in 1910 and 1915. Mary Emma then moved in with her widowed brother, William, to help care for his son George. After William died and George reached adulthood, she returned to Locust Knoll to keep house for her brother Howard.

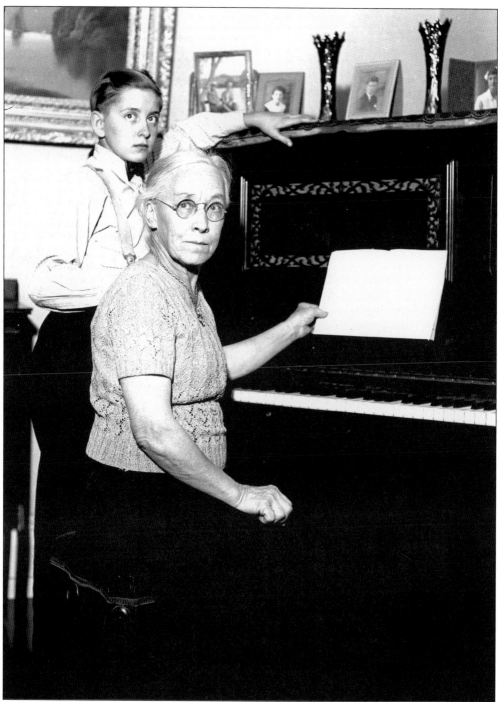

Mary Emma Seal and Eleanor Seal, c. 1930. Mary Emma (seated) was a member of Brandywine Baptist Church and is remembered as a good cook and accomplished pianist. She died in 1941 at the age of 75. Here Mary Emma poses with her grandniece Eleanor Seal, who was known to her friends as Norn. As can be seen in this picture, Norn usually wore boy's clothing at home.

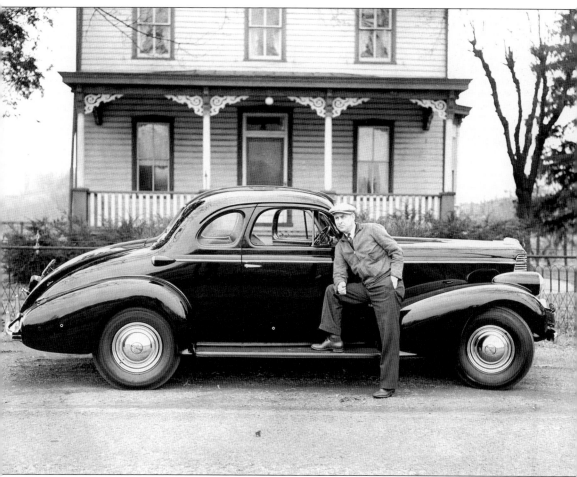

EDWARD SEAL WITH HIS OLDSMOBILE, C. 1938. Edward J. Shimer Seal (1896–1955)—who was usually behind the camera—takes a moment to pose with his 1938 Oldsmobile. Seal was the son of Howard Ellsworth Seal and Annie L. Shimer. Edward grew up in Chadds Ford on Locust Knoll Farm, and moved to this house with his father in 1929. He later lived at Granogue, Delaware, with his brother William H. Seal, who worked there for Irénée du Pont Sr. At one time, Edward Seal worked as a chauffeur for the Luke family of Rocky Hill Farm. A perennial bachelor, he was a member of the American Trap Shooters Association and was a talented amateur photographer. (Many of his photographs are featured in this book.) Edward died at the age of 58 and is buried in Birmingham Cemetery.

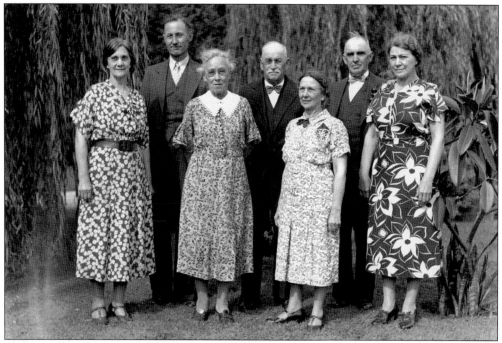

A GROUP PORTRAIT, C. 1940. Mary Emma Seal is the second woman from the left in the first row. Howard E. Seal Sr. is the second man from the left in the second row. The other people are not identified.

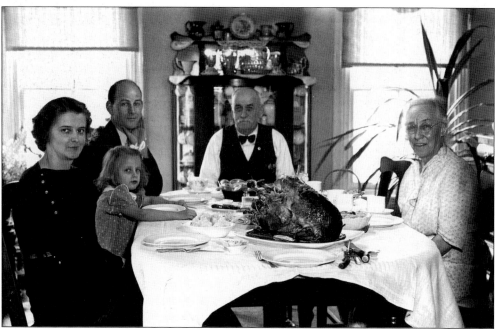

A FESTIVE DINNER AT THE SEAL HOME, C. 1930. Family members are seated, and the turkey stands ready to be carved. From left to right are Blanche E. Seal with daughter Janice; Blanche's husband, Howard E. Seal Jr.; her father-in-law, Howard Ellsworth Seal; and Mary Emma Seal. The photograph was taken by Edward J. Shimer Seal.

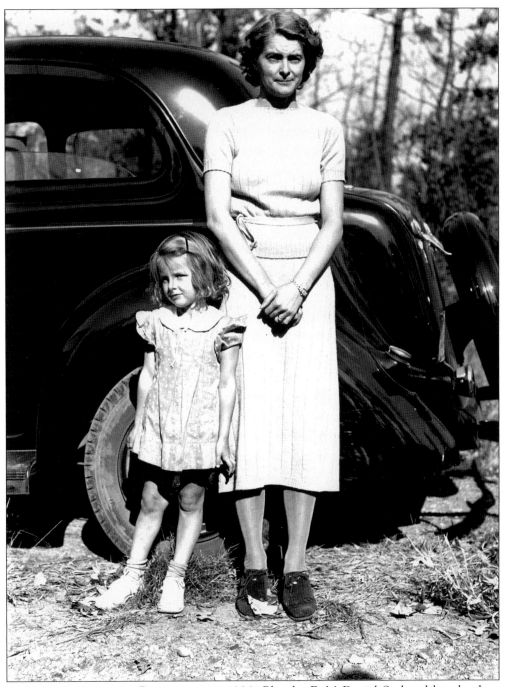

BLANCHE E. SEAL AND DAUGHTER, C. 1930. Blanche E. McDaniel Seal and her daughter Janice pose for the camera in front of the family car. Blanche was the wife of Howard Ellsworth Seal Jr., son of Howard Ellsworth Seal of Locust Knoll Farm. Howard Jr. ran a plumbing and heating business in McDaniel Heights, Delaware (along Route 202 near Fairfax).

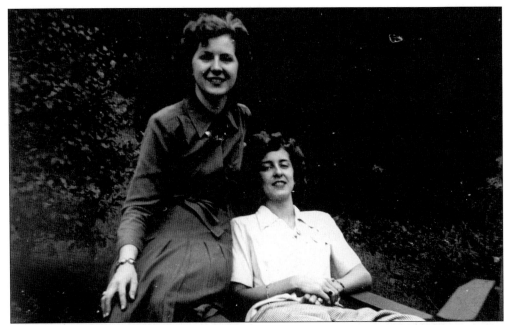

ANNA AND ELEANOR SEAL, 1944. Anna Seal (left), daughter of William H. Seal, grew up in Chadds Ford. After attending the Chadds Ford Consolidated School, West Chester High School, and West Chester State Teachers College, Anna became a teacher. She married H. Curwen Schlosser in 1943. Anna had fond memories of her great-aunt Mary Emma Seal, who told her many bedtime stories about dramatic happenings in the family history, Bible stories, plus some gruesome tales of robberies, deaths, and encounters with black snakes while berry picking. Anna's sister Eleanor is on the right. (Courtesy Jean M. Oakes.)

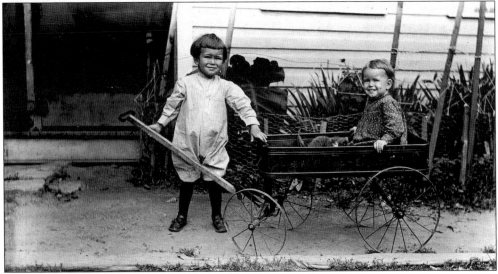

THE KEYSTONE EXPRESS, C. 1915. Two Chadds Ford children, thought to be members of the Welch family, halt their play for a moment to pose for the camera. Note the kitten in the Keystone Express wagon. Many people who grew up in Chadds Ford have fond memories of childhood activities: swimming and fishing in the Brandywine, games of hide-and-seek in haylofts, hunting, and riding bikes and horses.

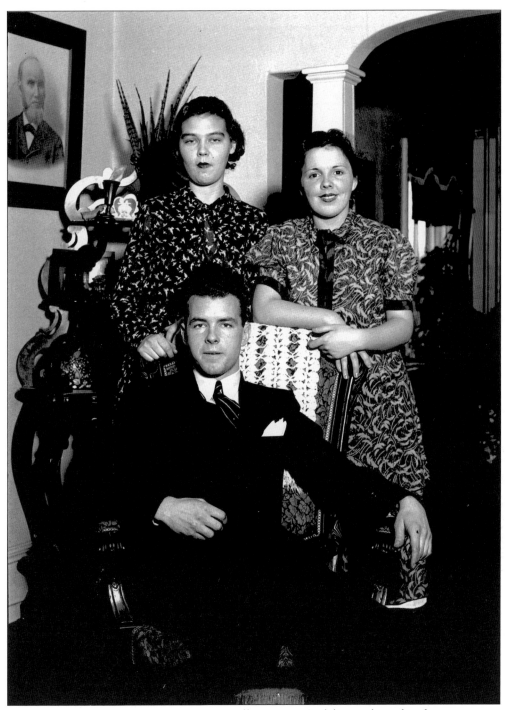

HARRY WELCH AND FRIENDS, C. 1940. William Louis Welch was the railroad stationmaster at Newport, Delaware, but he also had ties to Chadds Ford through his wife, Eva May Seal (daughter of Howard Ellsworth Seal Sr. and Annie L. Shimer). The Welches married on October 18, 1909, and had three boys: Harry, Louis, and Thurley. Son Harry is shown here with two unidentified female companions.

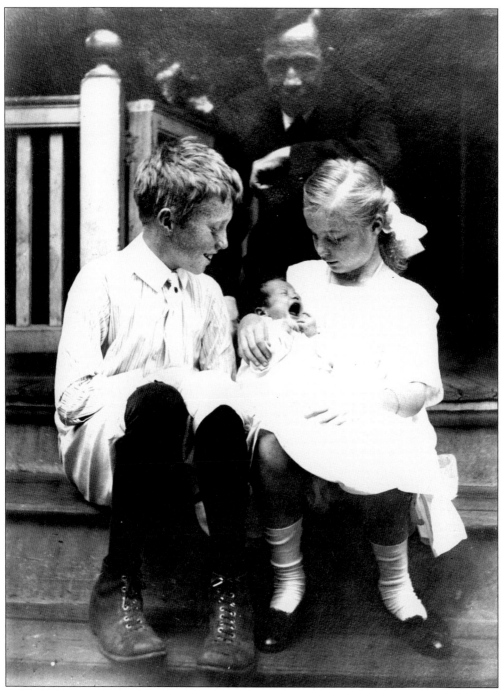

A New Baby, c. 1910. The Chadds Ford Historical Society has a number of photographs in its collection whose subjects are unidentified. This tender image features a family grouping of two children admiring a new baby.

Four

FARTHER AFIELD

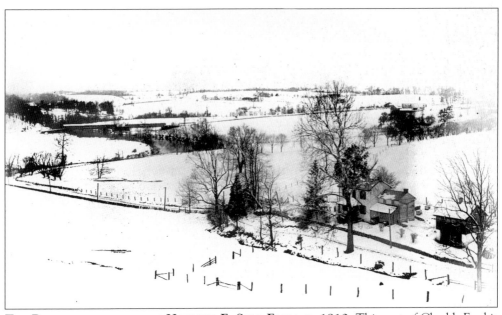

THE BRANDYWINE FROM THE HOWARD E. SEAL FARM, C. 1910. This part of Chadds Ford is untouched by new house construction and looks much the same today. The view is from Locust Knoll Farm toward the Twin Bridges, near the Big Bend of the Brandywine River just south of Chadds Ford. To the right is Locust Knoll Farm.

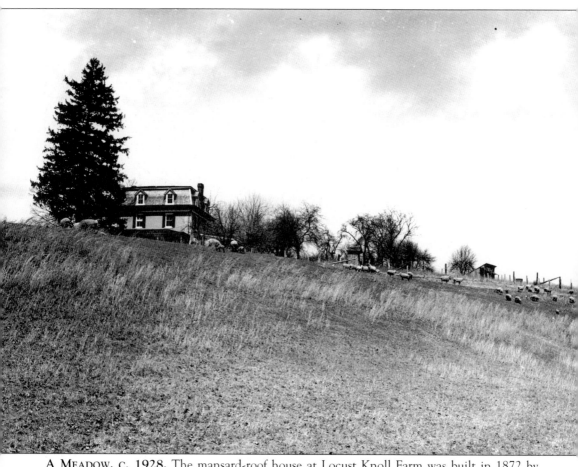

A MEADOW, C. 1928. The mansard-roof house at Locust Knoll Farm was built in 1872 by William Heyburn Seal; it probably replaced an earlier stone house. In 1854, William married Deborah Twaddell, whose great-grandfather William W. Twaddell ran a mill on the Big Bend property. In 1910, William Heyburn Seal died, leaving the 115-acre property to his son Howard Ellsworth Seal.

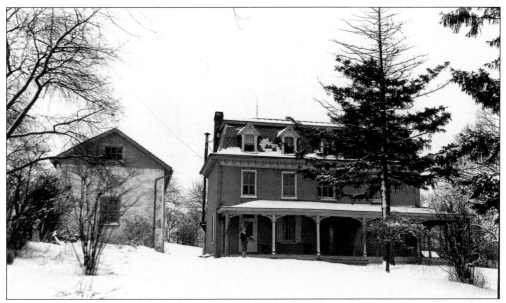

THE HOUSE AT LOCUST KNOLL FARM, C. 1928. Howard Ellsworth Seal lived at Locust Knoll Farm with his wife, Annie Shimer; their four children; and Howard's unmarried sister, Mary Emma. In 1929, Howard retired from farming, sold the property, and moved to a house on Route 100 just south of the railroad bridge and Route 1. His son William purchased the Thomas Wallace House on Station Way Road.

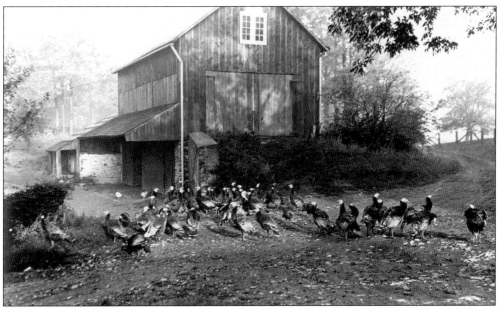

THE CARRIAGE HOUSE AT LOCUST KNOLL, C. 1925. The Seals were active in all areas of farm life. They tended large flocks of turkeys and chickens, kept bees (selling honey at 25¢ per pound), raised milk cows, made butter, grew corn, and canned fruit.

SALE DAY AT LOCUST KNOLL FARM, MARCH 1, 1929. After Howard Ellsworth Seal sold his Locust Knoll Farm, he held a public sale to dispose of his personal property. Included in the sale was farm equipment, such as his John Deere corn planter, a two-way Syracuse riding plow, and a milk wagon. Household goods, such as six Windsor chairs, two rocking cradles, and an Edison phonograph with large wooden horn and records, were also offered. Seal parted with three general-purpose horses, one large black Percheron colt, and 100 chickens. Hired man Spencer Hovington (1864–1934), seen on the left, assisted with the sale.

JOHN ANDRESS, C. 1940. John G. Andress was born in Downingtown, and in 1909 moved to Chadds Ford, where he worked as a farmer at Locust Knoll. Later he took a position as a guard at the Delaware County Prison Farm. He died in 1947.

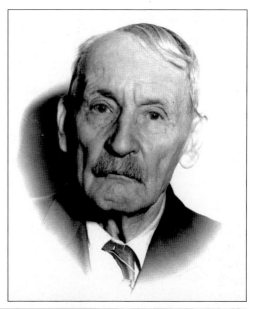

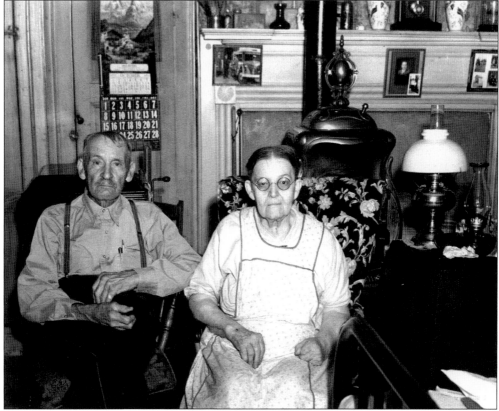

MR. AND MRS. JOHN ANDRESS, 1939. The Andress family lived off of Bullock Road. John is shown here with his wife, Elizabeth Hoopes, who was confined to a wheelchair in her later years. The couple had five sons: Fred H., Walter G., Frank J., Morgan M., and Thomas Butler Andress.

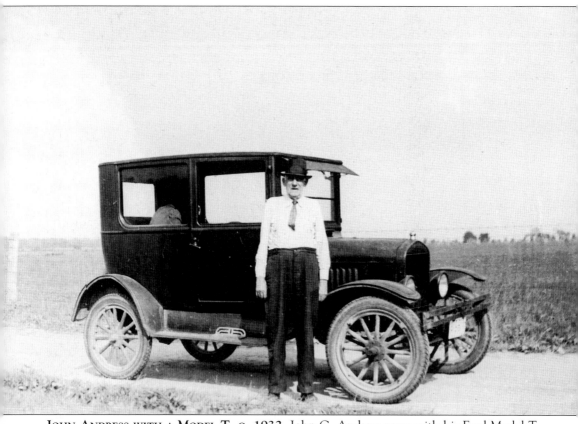

JOHN ANDRESS WITH A MODEL T, C. 1932. John G. Andress poses with his Ford Model T, which was probably made between 1924 and 1927. Billed as "high priced quality in a low priced car," a Model T could be purchased for $850 in 1908, and by 1925 could be had for only $260. During its production years between 1908 and 1927, the Model T was America's car of choice, with more than 15 million on the road. Sales literature from 1924 states, "Anticipation of a joyous, carefree vacation are abundantly realized when a Ford closed car provides easy access to town or country." Unfortunately, John Andress died from injuries sustained in an automobile accident.

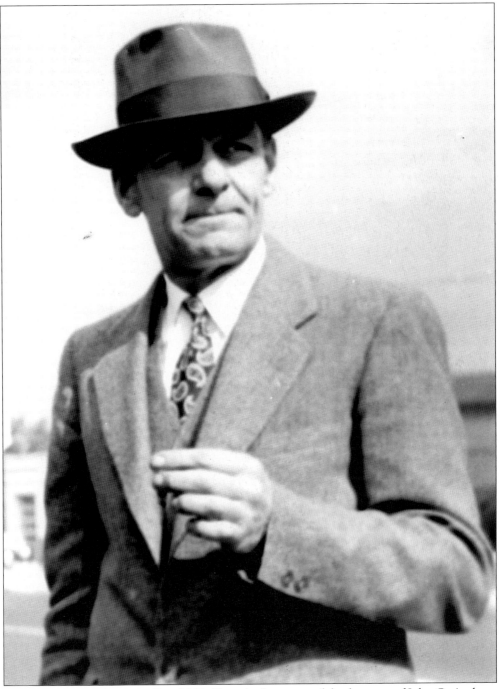

THOMAS BUTLER ANDRESS SR., 1948. Tom Andress, one of the five sons of John G. Andress, shared his father's love of automobiles. He was a mechanic who worked at Brittingham's Garage, at the northwest corner of Routes 1 and 100. Tom married Hannah Shaud and had one son, Thomas Butler Andress Jr. The family lived in the bungalow on Station Way Road, one house south of the brick building that is today home to Gentry's Tack Shop. Tom is remembered for his kindness and great sense of humor.

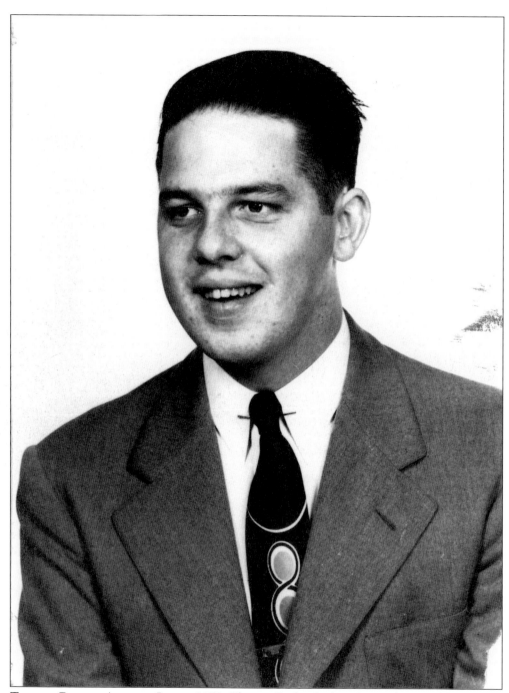

THOMAS BUTLER ANDRESS JR., C. 1950. Thomas Butler Andress Jr. was born in Chadds Ford to Thomas Butler Andress Sr. and his wife, Hannah, in March 1928. He was a premed major in college, but his schooling was interrupted by the Korean War. After serving in the military, Andress became a chemist and worked at ICI (Imperial Chemical Industries). He never married.

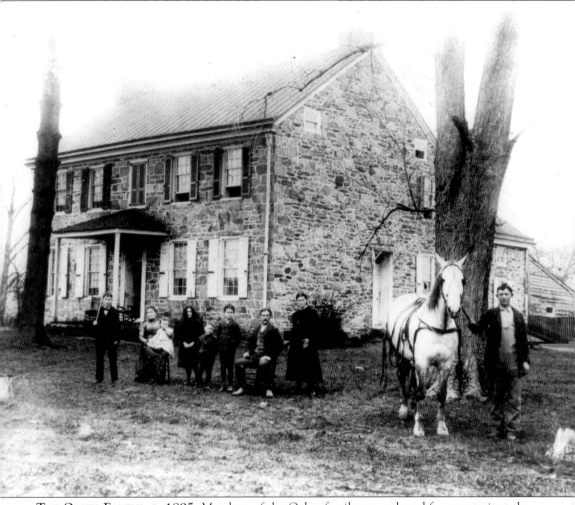

THE OAKES FAMILY, C. 1895. Members of the Oakes family are gathered for a portrait at the Cherry Farm, located on Dilworthtown Road off Route 202 in Thornbury Township. The family rented the property *c.* 1895. From left to right are George Oakes, Margaret Welch (Oakes) with baby Lane, Elizabeth Oakes (Potier), James Oakes, Frank Martin Oakes (1887–1966), Frank Peirce Oakes, Florence Oakes, and Ira Joseph Oakes (with the horse).

JACK OAKES, C. 1940. Lane Oakes (seen as the babe-in-arms in the previous photograph) and his wife, Marian Leary Oakes, had three children: Lane, Jack, and Betty. The boys were musical—Lane played the trumpet and Jack played the drums—and both performed with Chris Sanderson's Pocopson Valley Boys. The family lived on Station Way Road and was friendly with the Seal family.

ROSE AND FRANK OAKES, 1941. Rose Mary Shaud Oakes and Frank Martin Oakes pose inside Jimmie John's Hot Dog Stand. Frank and Rose had five children: Francis, Jean, Ira, Joseph, and George. Frank was the manager at Joseph Luke's Rocky Hill Farm in the 1920s. (Courtesy Jean M. Oakes.)

ANNA SEAL SCHLOSSER AND JEAN M. OAKES, OCTOBER 1944. Jean (right), daughter of Frank and Rose Oakes, grew up at Rocky Hill Farm. As an adult, she was employed by the Chester County Hospital in several administrative positions. After 43 years of service, she retired as executive vice president. Jean's friend from first grade, Anna Seal, also grew up in Chadds Ford. At the time this photograph was taken, Anna was staying at the Granogue estate in Delaware, where her father was working. Her husband, Curwen Schlosser, was overseas in the military. (Courtesy Jean M. Oakes.)

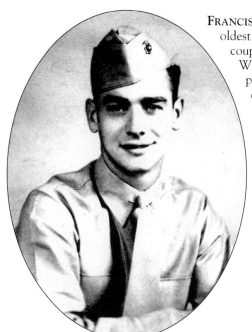

FRANCIS MARTIN OAKES, C. 1940. Francis was the oldest son of Frank and Rose Oakes. All of the couple's five children were delivered at home by Dr. William Betts. Medical receipts still in the family's possession reveal the doctor's fees for the deliveries: $20 for Francis in 1918, $27.50 for Jean in 1920, $24 for Ira in 1921, $31 for Joseph in 1924, and $30 for George in 1926. Francis served in the U.S. Marine Corps during World War II as a private first class. He married Margaret Jane Thomas and had two sons. He was employed by Westinghouse Corporation. (Courtesy Jean M. Oakes.)

IRA JOSEPH OAKES II, C. 1940. Ira Joseph Oakes II, third child of Frank and Rose Oakes, was named for his father's brother, who ran a dairy farm in Chadds Ford and was a county commissioner. Ira joined the army during World War II and became a sergeant in the 34th Red Bull Infantry Division. He was wounded at the Battle of Casino in Italy and was awarded a Purple Heart. Ira settled in West Chester after the war and married Mary Short. The couple had six children. Ira worked as a rural mail carrier for 35 years. (Courtesy Jean M. Oakes.)

JOSEPH LUKE OAKES, C. 1940. Joseph Luke Oakes was born in Chadds Ford in 1924 to Frank and Rose Oakes. He was named for Joseph Luke of Rocky Hill Farm. Joseph served as a corporal in the army during World War II, with tours in Panama, Burma, and India, and later re-enlisted to serve in the Korean War as well. He married and had one son, and worked as a house painter in West Chester. (Courtesy Jean M. Oakes.)

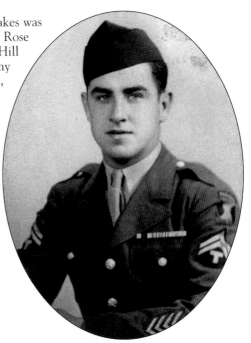

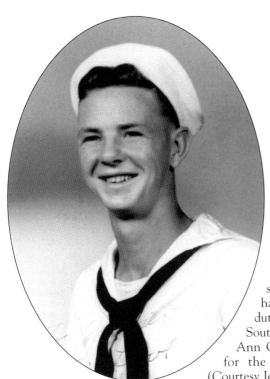

GEORGE OTLEY OAKES, C. 1940. Born in 1926 to Frank and Rose Oakes, George served in the navy during World War II and had the rank of yeoman third class. His tour of duty took him to many places, including the South Pacific. After the war, he married Betty Ann Chambers, had eight children, and worked for the Wyeth Laboratories in West Chester. (Courtesy Jean M. Oakes.)

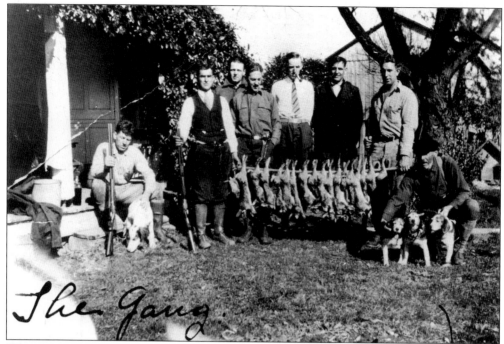

"THE GANG," 1939. "The Gang" is seen after a day of rabbit hunting. Kneeling at the right is John Andress, and seated at the left is one of his sons. Standing from left to right are Frank M. Oakes, Tom Andress, three unidentified Andress brothers, and Joseph Luke.

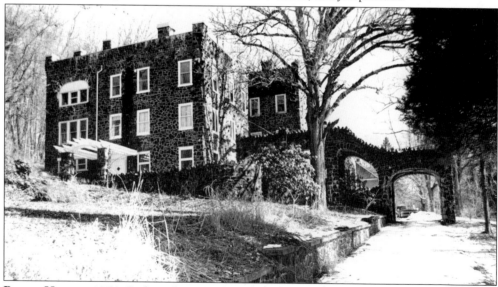

ROCKY HILL, C. 1950. Built in the 1870s by Joseph Garthrope, Rocky Hill was later owned by several generations of the Martin family (from Philadelphia), who used this 200-acre working dairy farm as a country residence. Under the ownership of Joseph Martin, the Victorian house was transformed into a castlelike structure. The property was located between Route 100 just south of Chadds Ford and Bullock Road, with entrances on both roads. What had been the main entrance to the home is now called Camly Lane. Joseph Chandler Luke purchased the farm in the early 1920s. (Courtesy Delaware County Planning Department.)

JOSEPH CHANDLER LUKE, C. 1925. Joe Luke was born on May 6, 1898, in Luke, Maryland. He married Dorothy Pitt Smith of Wilmington, Delaware, in 1923. Their children were Joseph Chandler Luke Jr., Jane Chandler Luke, and Natalie Ray Luke. Joe also had two brothers, William D. Luke and James L. Luke Jr. In 1939, Joe moved to Hollywood, Florida, where he became director of the First National Bank of Hollywood and the Federal Savings and Loan Association of Hollywood. He died in 1962 at the age of 64.

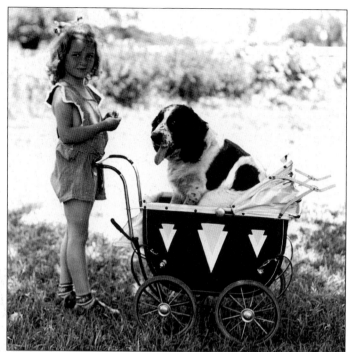

JANET PENDLETON LUKE, c. 1925. Janet Pendleton Luke pushes her dog in a baby carriage at Rocky Hill Farm. Janet was the daughter of James Lindsay Luke Jr., Joe Luke's brother, and lived nearby in Wilmington, Delaware.

ROBERT HEMPTON, C. 1925. Robert Hempton was born in County Tyrone, Ireland. He emigrated first to Canada and, in 1923, to the United States, where he settled in Wawa. He was soon hired by Joseph Luke to work at Rocky Hill Farm as a handyman and gardener. Robert married Jessie Coppin and had two sons, Walter and Desmond. When the Lukes moved from the estate in 1939, Robert was hired as the custodian for the Chadds Ford Elementary School. He was a member of the Brandywine Baptist Church and is buried in the cemetery there.

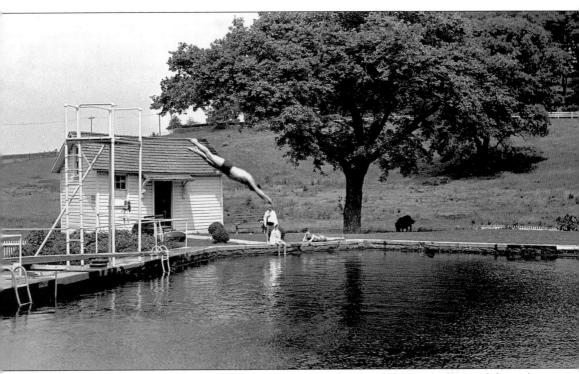

SWIMMING IN LUKE'S POOL, C. 1925. Joseph Luke of Rocky Hill Farm had one of the only swimming pools in Chadds Ford. It was a freshwater pool formed by a stone dam along a creek. Today the pool is largely silted over.

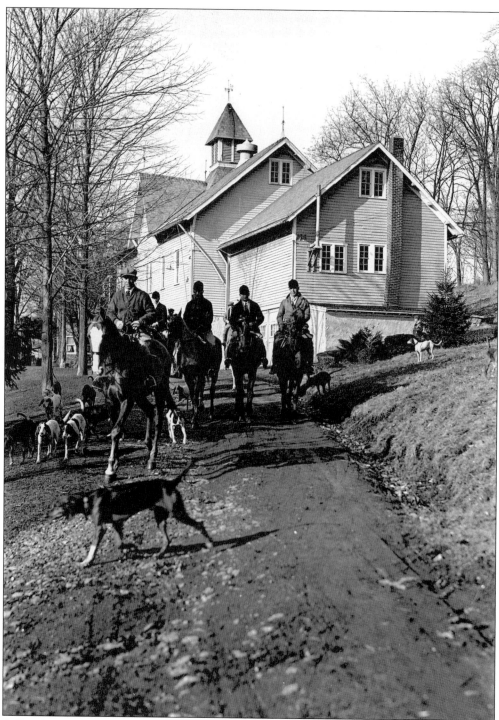

A Fox Hunt Group with Hounds, c. 1920. Joseph Luke maintained his own private pack of hounds at Rocky Hill Farm. Here the hounds, horses, and riders leave the stable area. Fox hunting was a longstanding tradition in Birmingham Township under Charles E. Mather and his Brandywine Hounds, until 1964, when the pack was moved to Pocopson Township.

MARTIN BUCKLEY, C. 1925. Martin Buckley was Joe Luke's huntsman at Rocky Hill Farm; he was responsible for the care of the horses and hounds. Martin and his family lived on the farm in a small bungalow.

THE EDWARD BRINTON HOUSE, C. 1900. Built in 1839 by Edward Brinton (1780–1849), this house is located on Route 100 just north of Brinton's Bridge Road. Several generations of Brintons subsequently lived here, until the house was sold in 1876 to Sellers Hoffman. Ownership of the property later passed from Sellers to his son William A. Hoffman and some years later to Ralph Hoffman, grandson of Sellers. In 1957, the home was purchased by Mr. and Mrs. Edward Ralston, who named the house Keepsake. The people in this photograph are probably members of the Hoffman family. (Courtesy Sonia Ralston.)

ELLWOOD MENDENHALL, C. 1870. Quaker Ellwood Mendenhall was justice of the peace from 1850 to 1860, during the period of the Fugitive Slave Law. Family lore relates his efforts to thwart slave hunters seeking warrants to search the house of his brother and sister-in-law, Isaac and Dinah Mendenhall, who were active in the Underground Railroad. Ellwood delayed the slave hunters by sending them on a circuitous road route, and meanwhile, sent a runner the short distance across the field to warn Isaac and Dinah. By the time the slave hunters reached the house, the slaves had been hidden or moved. (Courtesy Frank Mendenhall.)

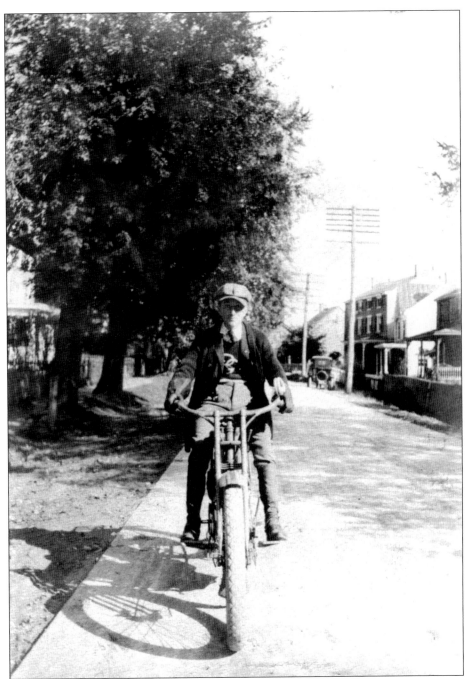

EDGAR MENDENHALL, C. 1916. The teenage Edgar Mendenhall, grandson of Ellwood Mendenhall (seen in the previous photograph), liked to ride his motorbike along the railroad tracks on his way to school in Kennett Square. This photograph was probably taken in Hamorton at the intersection of Routes 1 and 52. As an adult, Edgar took over Springdale, the family farm, in 1916 and ran the dairy operation until he disbanded it in 1949. There were 30 milking cows and two teams of horses at the farm. Edgar's son, Frank, still lives on the family property. (Courtesy Frank Mendenhall.)

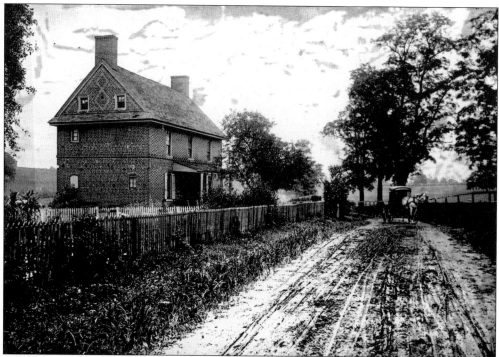

THE BARNS-BRINTON HOUSE, C. 1900. The Barns-Brinton House was built by tavernkeeper William Barns in 1714, with a tavern and sleeping quarters for travelers on one side and privacy for the family on the other side. Barns, also a practicing blacksmith, was perhaps the creator of some of the original hardware that is still in the building. From 1753 to 1859, the property was owned by several generations of Brintons.

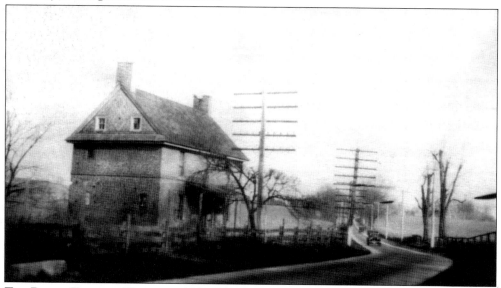

THE BARNS-BRINTON HOUSE, C. 1920. The Barns-Brinton House was restored by the Chadds Ford Historical Society in the early 1970s, and today functions as a historic house museum. In this east-facing view, it is interesting to note that Route 1 passes by the south (front) side of the house. In 1938, the road was relocated to the north (back) side of the house.

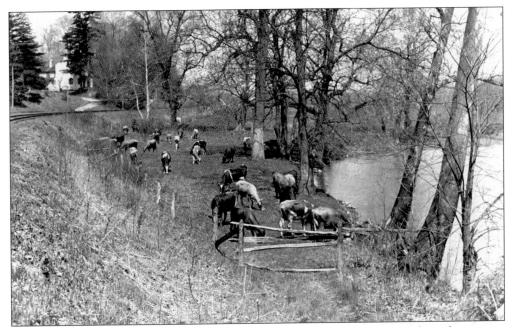

COWS ALONG THE BRANDYWINE, C. 1940. The cows in this meadow graze along the western side of the Brandywine in Pennsbury Township, northwest of Brinton's Bridge. The herd was part of the Stellwagon farm, just north of the Way house, seen in the background. The original section of the Way house was built in the 1700s by Jacob Way. The house was expanded *c.* 1870 and was subsequently remodeled several times.

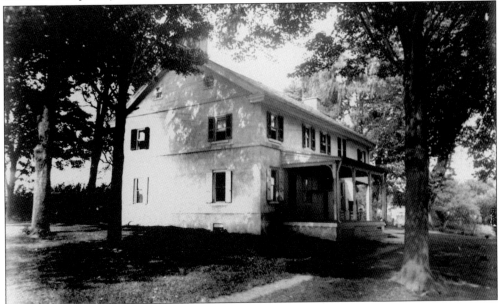

THE GEORGE GILPIN HOUSE, C. 1925. Built in 1754 and added on to twice, this house is located on Harvey Road in Chadds Ford Township and is a private home. After the Battle of Brandywine, British general Sir William Howe occupied the house for five days, reportedly staying in the northwest bedroom. Here, Howe received the American doctor Benjamin Rush, who came to help the wounded. (Courtesy Louis R. Wonderly.)

A Darlington Family Portrait, c. 1924. Seated are Mary Parker Darlington (c. 1864–c. 1930) and her husband, Emlen Darlington (c. 1866–1949). Their children stand behind them. From left to right are Edith, Horace, William, Frances, and Hannah. The Darlingtons were farmers who lived on Hillhurst Farm, on Pocopson Road just south of Route 926. The farm is still in the family. Hannah and Frances became teachers, William took over the family farm, and Horace practiced medicine in West Chester. (Courtesy Janet Darlington Haldeman.)

THE WINFIELD FAMILY HOME, C. 1915.
The Winfield House was located along
the northeast side of Route 1, about two
miles south of the intersection with
Route 202. It was torn down in the 1990s.
Susan Winfield was employed by Richard
Mead Atwater soon after the Atwaters
moved to Chadds Ford in 1906. Susan
worked first in the milking barn and then
in the kitchen of Lafayette Manor. Her
son Gilbert went to the Chadds Ford
Consolidated School and is remembered
as a talented basketball player.

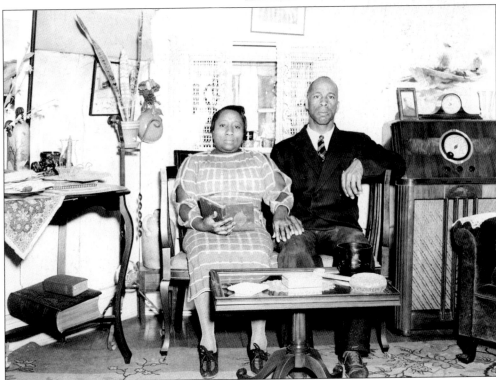

MR. AND MRS. WILLIAM LOPER, 1941. Alice Hovington Loper, daughter of Spenser
Hovington (who worked for Howard E. Seal at Locust Knoll Farm), poses here with her
husband. The couple lived for a time in the old Winfield House along Route 1 (previous
photograph), where they often held church suppers.

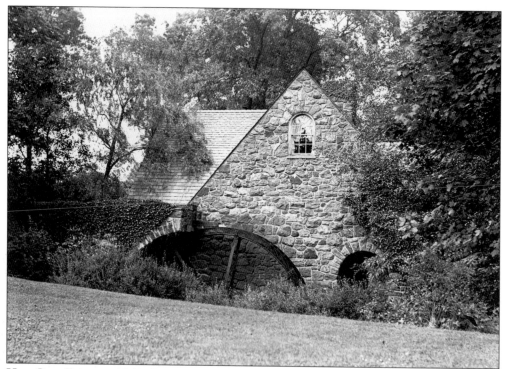

HILL GIRT FARM, C. 1940. Starting in 1910, Harry G. Haskell Sr. purchased five different farms in the area along Route 100 south of the Twin Bridges. He called the consolidated 900-acre farm Hill Girt. An executive at the DuPont company, Haskell had varied interests, including showing flowers, running a dairy farm, raising sheep, and breeding dogs. Today, Haskell's grandchildren run profitable businesses growing vegetables and boarding horses.

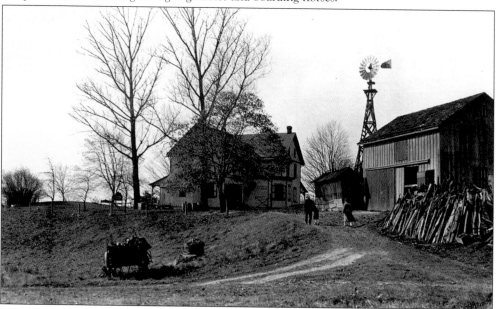

THE SHIELDS PROPERTY, C. 1940. This property adjoined Locust Knoll Farm near the Twin Bridges, Seal Farm, and the Big Bend. It was owned by Charles Shields.

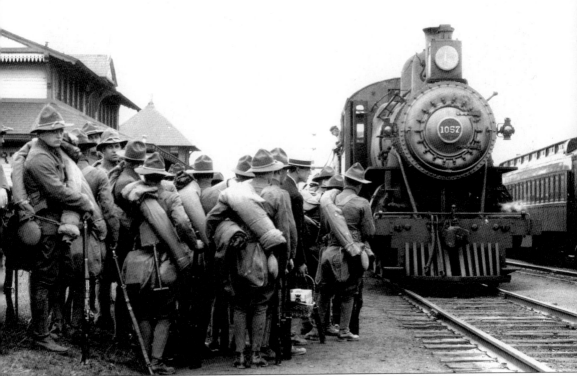

BASE 38 UNIT BOARDING TRAIN, C. 1918. During World War I, Base Hospital Corps 38 was encamped for field training at the Martin Farm, just south of Chadds Ford between Bullock Road and Route 100. The farm was later called Rocky Hill (owned by the Luke family) and is now a housing development. In this view, the soldiers line up to board the train at Brandywine Summit, bound for Philadelphia before deployment overseas. (Courtesy the Christian C. Sanderson Museum.)

LENAPE PARK, C. 1925. Lenape Park was established in the early 1900s by the West Chester Street Railway Company, which ran a trolley from West Chester. The large lake area became a popular picnic and boating spot. Cottages were built along the banks of the Brandywine.

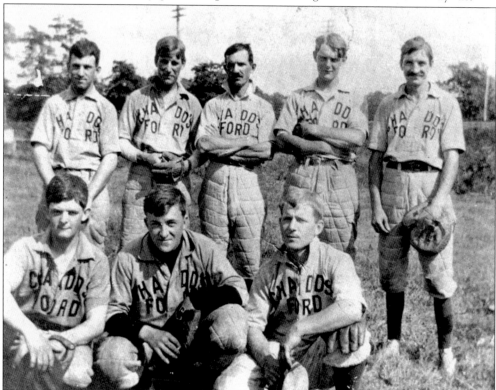

THE CHADDS FORD BASEBALL TEAM, JULY 4, 1906. Like many other towns, Chadds Ford had its own baseball team. Pictured here are, from left to right, the following: (first row) Erskine Baldwin, "Tank" Baldwin, and Chandler "Tug" Arment; (second row) J. Harlan Pyle, "Timber" Andress, Harry Arment, Bill Swayne, and Harry "Pete" Johnson.

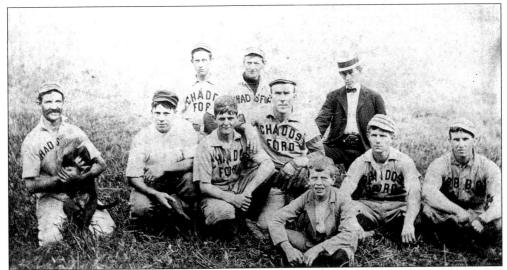

THE CHADDS FORD BASEBALL TEAM, 1906. From left to right are the following: (first row) Richard Lindley Baldwin; (second row) Pete Johnson, Joe Roberts, Erse Baldwin, and three unidentified players; (third row) Sellers Hoffman, unidentified, and George Newlin.

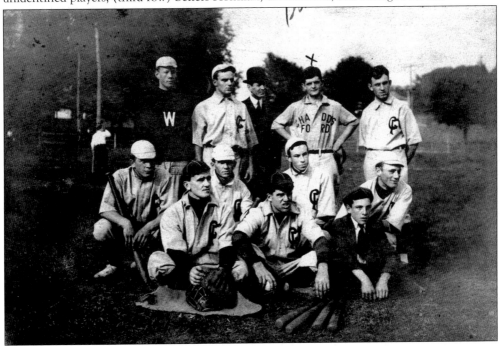

THE CHADDS FORD BASEBALL TEAM, 1909. N. C. Wyeth took this photograph at a 1909 game between Chadds Ford and Concord. On the back of the picture he recorded the final score— 5–1 in favor of Chadds Ford—and listed the Chadds Ford players and their positions: H. Pyle, left fielder; H. Scheidt, right fielder; I. Arment, first baseman; C. Husbands, catcher; F. Hoffman, center fielder; W. Seal, third baseman; A. Wallace, second baseman; L. Wallace, shortstop; and B. Briscal, pitcher. Also listed were Martin Pyle, mascot; E. Baldwin, manager; and F. Andress, umpire. In the 1909 season, Chadds Ford played 24 games and won 17. One game ended in a tie, called in the 11th inning to allow the visiting team to catch the train home.

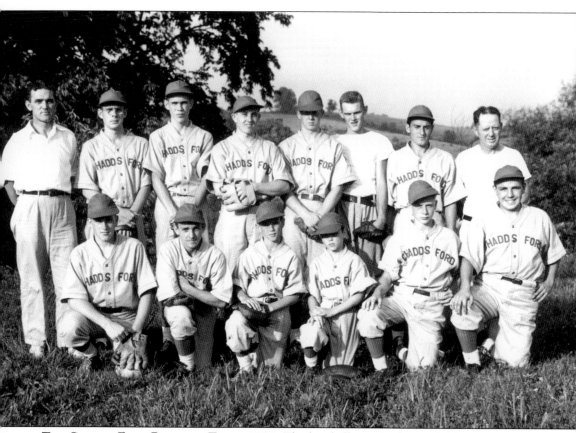

THE CHADDS FORD BASEBALL TEAM, 1939. The baseball team's playing field was located at the southeast corner of Routes 1 and 100. There is still a meadow there today. From left to right are the following: (first row) Bill Wylie, Carmen DiGuglielmo, Lane Oakes Jr., unidentified, Paul Touchton, and Francis Watson; (second row) Lane Oakes, Herb Guest Jr., Frank Guest, Harry Arment, Bill Miller, Bill Swayne, unidentified, and W. Edwin Miller.

Five

SCHOOL DAYS

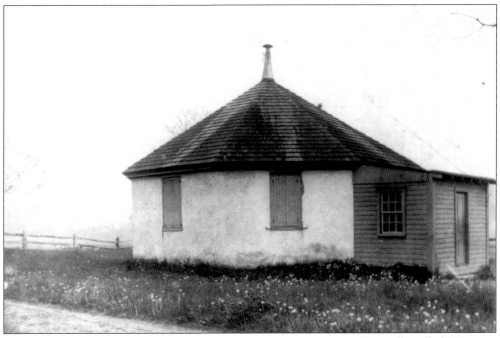

THE OCTAGONAL SCHOOL AT BIRMINGHAM MEETING, C. 1950. Originally called Harmony Hall, this eight-sided structure was built in 1818 and served as a schoolhouse until *c.* 1905. Until 1838, only male teachers were hired, but after that year, female teachers were permitted to teach girls during the summer months. After 1905, the building was used for Sunday school classes, as a township voting place, and for other public purposes.

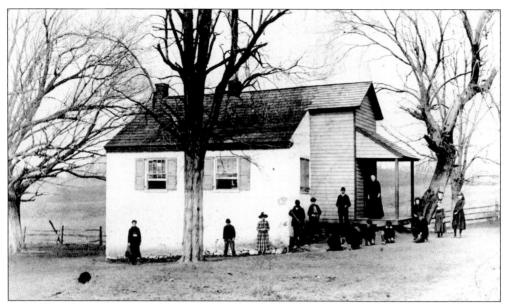

SMITH BRIDGE SCHOOL, C. 1870. Smith Bridge School, also called Beaver Valley School and School No. 4, was built *c.* 1850. It stood at the northeast corner of Smithbridge and Ridge Roads. The school closed *c.* 1908 and was demolished in 1915. Only a few of those pictured here have been identified. From left to right are the following: (standing) Mary Watkin, A. Barrett, A. Jenkins, ? Baynard, ? Jenkins, unidentified, Mabel Scott, two unidentified, and ? Kelley; (kneeling) unidentified, Nathaniel Watkin, two unidentified, Isaac Watkin, and unidentified.

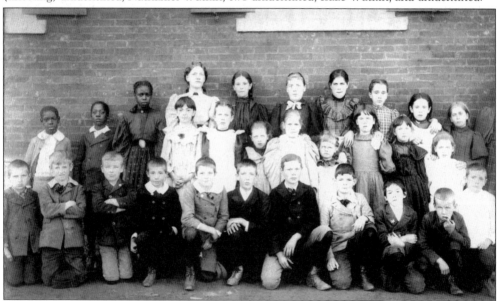

A SCHOOL PICTURE, C. 1900. The school where this photograph was taken is unidentified, as are most of the students. Richard Lindley Baldwin is fifth from the left in the first row. His brother Erskine Baldwin is the third from the right in the first row. Erskine was killed in a fireworks accident when he was about 21. Their sister Helen is fifth from the left in the top row. She was killed while crossing a railroad track in Hamorton, but saved the baby daughter she was carrying by throwing her from the path of the train.

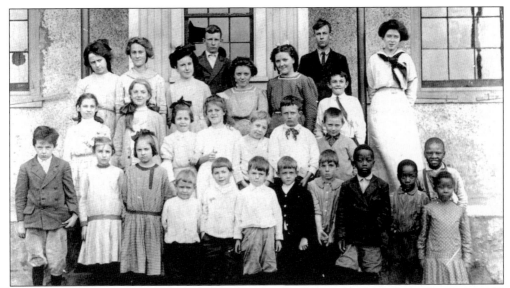

LOWER BIRMINGHAM SCHOOL, C. 1910. Lower Birmingham School was located on Route 100 about a quarter-mile south of Route 1, where the road veers sharply to the west. The building was later used as a studio and home for the Andrew Wyeth family. Here, students pose for their class picture. None of the students are identified except for Edward J. S. Seal, who stands at the top right next to the teacher.

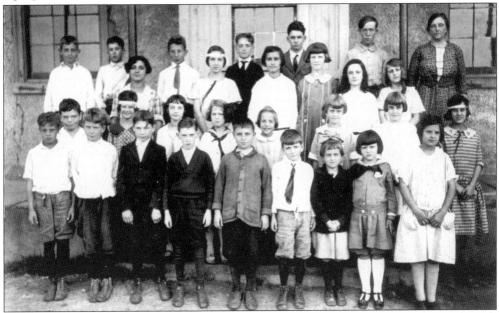

LOWER BIRMINGHAM SCHOOL, 1923. From left to right are the following: (first row) Walter Wilson, Billy Seal, unidentified, Jim McGinley, Marino Plebani, Brinton Kipe, Margaret Lippincott, Jean Mack, and Ellen Wilson; (second row) Richard Passmore, Myrtle Lynch, Isabel Hamby, Betty Seal, Marie Wilson, Charlotte LeFevre, Sara McMaster, and Mildred Lynch; (third row) Lemual McMaster, unidentified, Anna Ranio, Paul Bitting, unidentified, Vincent Talley, Emma Arment, unidentified, Henrietta Herring, Dottie Brittingham, Alfred Wickes, Marie Bullock, and teacher Annabell Clark. (Courtesy Margaret Winkler.)

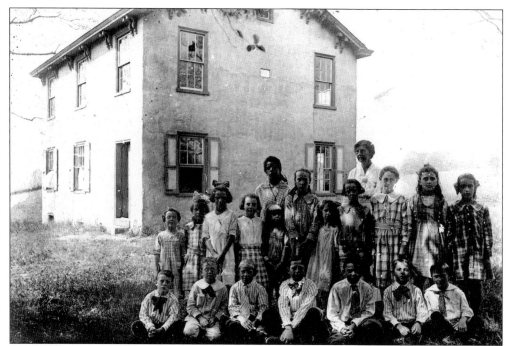

PARKERSVILLE SCHOOL, 1919. Located on Parkersville Road in Pennsbury Township, the school closed in 1925, when the Chadds Ford Consolidated School was built. This building was later used as a mushroom house and is now a private home. From left to right are the following: (first row) Rowland McFadden, Pascall Webb, Eddie Fraim, Horace Darlington, George Fraim, William Darlington, and Bob Hyatt; (second row) Dorothy Webb, unidentified, Marion Webb, ? Carville, Jean Brown, Frieda McMullan, Jane Brinton, Mary McMullan, Marjorie Webb, and Dorothy Brown; (third row) ? Boddy and teacher Jennie Darlington.

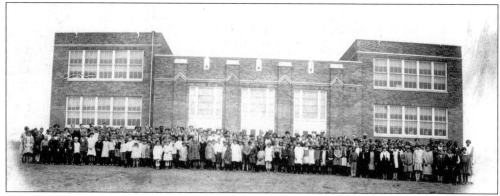

CHADDS FORD CONSOLIDATED SCHOOL, 1925. This school opened in the autumn of 1925, with Webster C. Herzog as the supervising principal. A donation of $50,000 from Pierre S. du Pont toward the cost of the building and the gift of the land by Swithin C. Walker helped get the project completed. The new consolidated school replaced several smaller schoolhouses, including Hickory Hill School, Cossart School, Central School, and Parkersville School. Students were taught up to the 10th grade only. After that, they were assigned to attend West Chester, Unionville, or Kennett Square high schools. When the Unionville and Chadds Ford school districts merged in 1954, this school became an elementary school for grades one through six. Expansions were completed in 1958, 1970, and 2003.

THE FOURTH-GRADE CLASS, 1931. From left to right are the following: (first row) John Talley, Charles ?, Ira Joseph Oakes, William Wylie, ? Lister, Ernest DeVoe, and George Wood; (second row) unidentified, Betty Wiggins, Betty Brown, Sara Pearson, Florence Talley, Rena Di Donato, Sara Kipe, Hazel Lynch, Ann Sheffield, and Esther Taylor; (third row) unidentified, Anna Zebley, Margaret Roddy, unidentified, Velma Sweed, Betty Buckley, Virginia Hill, and ? Lister; (fourth row) Calvin Highley, Ruth Cockerham, James Warrington, Walter Forwood, three unidentified boys, Norris Lyons Shaffner, and Richard Murphy. Mrs. Herzog (not pictured) was the teacher. (Courtesy Jean M. Oakes.)

THE SIXTH-GRADE CLASS, 1931. From left to right are the following: (first row) Sylvester Flerx, Fred Taylor, John Plebani, John Hollingsworth, Alvin McBride, and Jewell Hayes; (second row) Anna Seal, Mary Sharpless, Mary Chamberlin, Edna May Schwalm, Jean Oakes, Elizabeth Hickman, Rita DiGuglielmo, Edith Sheffield, and Ruth Talley; (third row) Andrew Graham, Raye McVey, Dorothy Knapp, Elsie Wallace, Lois Brooks, Greta Talley, and Christian Flerx; (fourth row) Richard Fernandez, William Cockerham, Harry Wright, Austin Robinson, Rueben Money, Robert Highley, Harold Hale, and Isaac Chamberlin. (Courtesy Jean M. Oakes.)

THE SEVENTH-GRADE CLASS, 1931. From left to right are the following: (first row) Ellis Pierson, Robert Murphy, Francis Oakes, Duane Webb, Robert Wylie, and Norman ?; (second row) Mary Zimmerman, Margaret Taylor, Dorothy Graham, Grace Tally, Filomena Rabbitiona, Sydney Pierce, Frances Clanton, Marian Way, Adeline Mayor, and Rosalie Gray; (third row) Charles Wallace, Jane Pyle, Mildred Gregg, Angelina Fernandez, Katie Roe, and James Winfield; (fourth row) William Money, Ray Clanton, Richard Ryan, Robert Wilson, James Whitaker, and Allen Douglas. (Courtesy Jean M. Oakes.)

SCHOOLCHILDREN, C. 1910. The name of the school these children attended is unknown, but their identities were carefully recorded on the back of the photograph. From left to right are the following: (first row) Blythe Sturgeon and Sam Allen; (second row) Wilbur White, Edgar White, Harry Pyle, Rea White, John White, Edgar Moore, Emily Moore, ? Kiley, and John Moore; (third row) Seal White, Maggie Allen, Joe Kitchelman, S. Fairlamb (presumably the teacher), J. H. Pyle, Charles Sturgeon, unidentified, Frank Cloud, and John Melton.

AFTERWORD

Historical research is an ongoing process. The information presented in this book is just a start; there is much more to learn about the people and the history of Chadds Ford. The Chadds Ford Historical Society is committed to preserving records and artifacts, to interpreting the history, and to educating the public about the way of life in the Chadds Ford area. The society continues to seek new photographs and documents that will tell the story of Chadds Ford. If you have materials that may help us, let us hear from you. Likewise, if you can add pertinent detail to the captions in this book or are able to identify a photograph's subject or location, please contact us. We will make this information available at www.chaddsfordhistory.org. With your help, we can provide a richly detailed history of our town for future generations.

JOSEPH MESSERSMITH, C. 1975. In this wonderful shot by Alfred C. Webber Sr. taken at the historical society's annual Chadds Ford Days fair, Joseph Messersmith is dressed in Colonial garb as he demonstrates tinsmithing. He was present at the first Chadds Ford Days in 1958, which was held in the decrepit barn (now torn down) at the southwest corner of Route 100 south and Route 1. Although Chadds Ford's buildings have come and gone, its roads paved and widened, and its farms transformed into housing developments, one thing remains constant: the community has always been home to interesting and colorful people. If you have a Chadds Ford connection, please send us your photograph and biography to help us preserve the Chadds Ford of today for the residents of tomorrow.